Intuitive
PAINTING
WORKSHOP

Intuitive
PAINTING
WORKSHOP

Techniques, Prompts AND **Inspiration** FOR A **Year** OF **Painting**

Alena Hennessy

NORTH LIGHT BOOKS
CINCINNATI, OHIO
www.createmixedmedia.com

Contents

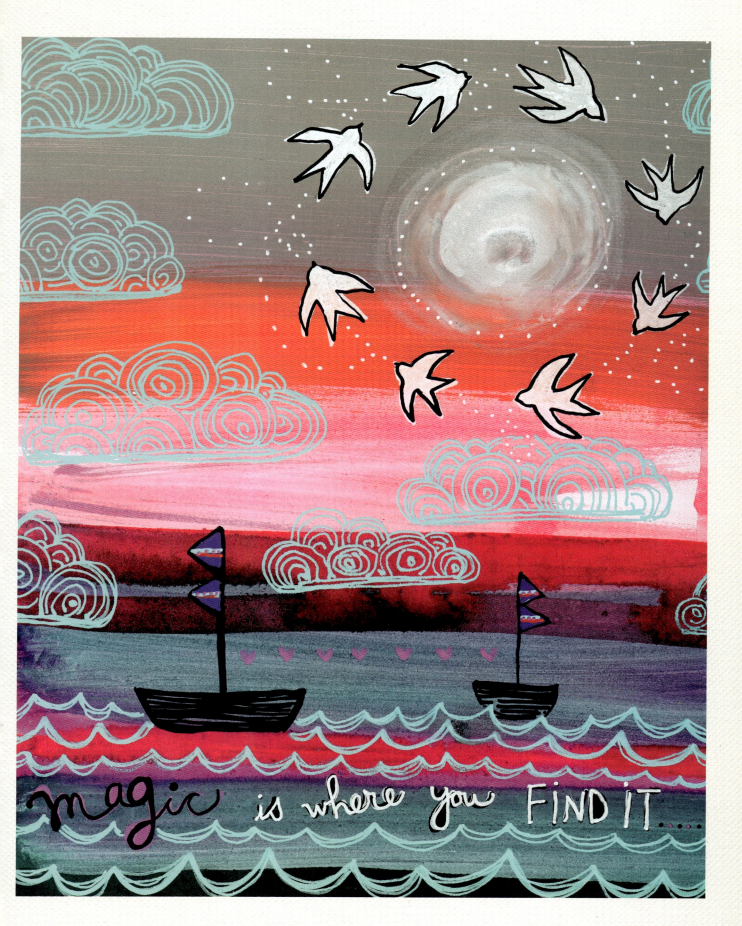

For additional downloads from the book, go to: CreateMixedMedia.com/IntuitivePaintingWorkshop.

5

Introduction
For the Love of Painting

I often share with my students that painting can be a metaphor for how one lives a life. Throughout my years of devoting myself to this fine craft, I have begun to see how there are certain steps to expect in the creative process or when you begin a new work.

In the beginning, when you first start a painting, you love it; it's full of wild possibilities; it's still open, unquestioned and ready for more attention. The work holds freedom; you begin instinctually (as we did when we were children), and you allow yourself to create with fewer concepts or expectations.

Then as more time passes and you go deeper into your process, the doubt comes up from within. You question your decisions; you feel unsure. You may even begin to feel stuck and not clear on how to move forward.

The painting has now entered the awkward stage, so you rework, refine and reinstate your intentions for this piece—however you may feel about it. This is a pivotal part of the process and a turning point within intuitive painting.

At this point some *surrender* needs to happen. There needs to be some letting go, and ultimately some trust needs to develop. This is when accepting and feeling akin to your inherent mark and visual voice are so valuable.

You learn with time to be more comfortable with who you are as an artist. You learn to trust your unique style of mark-making and painterly strokes.

This same scenario can play out in life in many ways. A risk is needed to feel unstuck; then breakthrough can take place, followed by more refinement, more details and finally acceptance. A planned painting may take a more strategic and technical approach. With intuitive painting, we feel our way, allowing the painterly marks, colors, lines, shapes and so forth to guide us forward in our creative process. We turn off the thinking rational mind and paint from pure impulse—we *feel* into the work. This is just how we created when we were children—and I feel there is a truth to be found within that. It's a process of allowing what comes, to witness our own understanding and to practice it again and again.

I have big love for the process of painting because it becomes a loyal friend, one that you will have for the end of your days, a place you can always go just for you. It provides quietude for the being, a mindful state, where you can unwind and almost meditate on a work.

It also brings you community (artist friends are truly the best); it can provide extra income and allows us to express what is beyond words. For ten years now I have been a full-time working artist, and I have seen time and time again how art can heal and transform lives.

Creating art is so innately human. I feel it is truly a gift you give to yourself. These are just my beginning thoughts on my love for painting. I encourage you to try it on, no matter your level of experience, and see what it does for you. I guarantee every time you sit down to paint, you will pick up and learn new things about yourself, new things about the process and gain slowly (with much practice) your own voice through this vast medium.

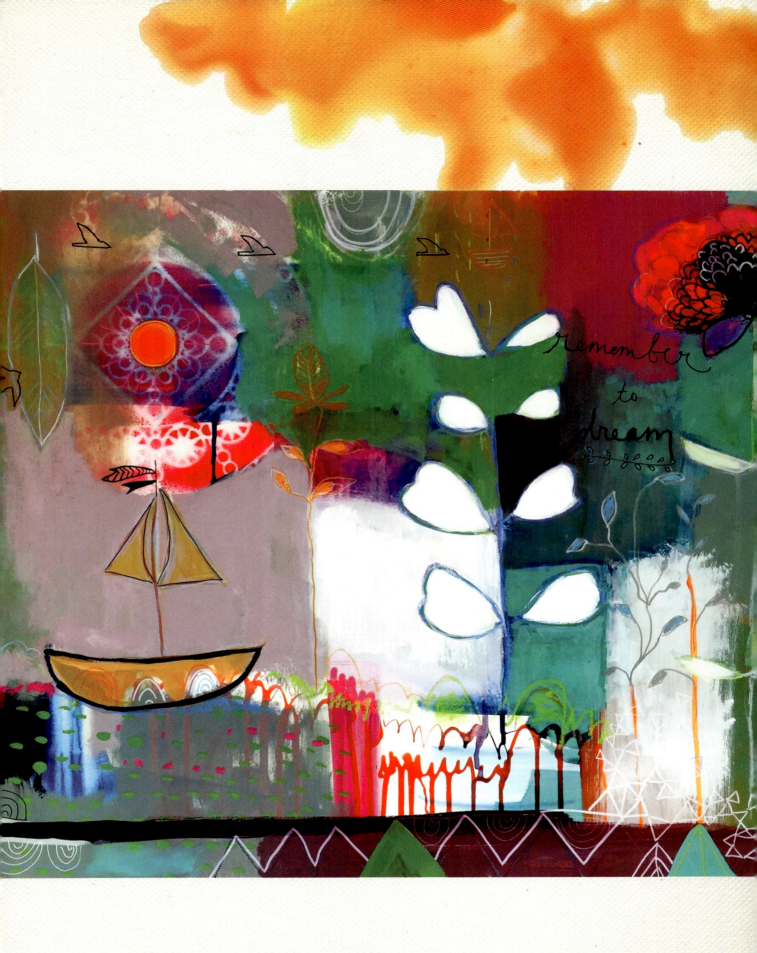

remember to dream

How to Get the Most out of This Book

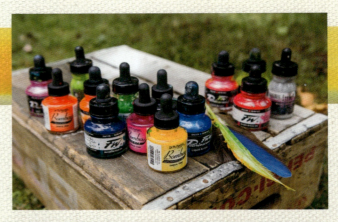

This book is a bit different than other how-to painting books out there. It is inspired by my popular online course, *A Year of Painting*, and includes the work of many of the wonderful artists who participated in the course, so you'll receive an array of approaches and styles as examples for each monthly lesson.

My mission is to keep you motivated to paint all throughout the year—and the lessons can help you do that. I also work in a free-spirited way, one that is without too much structure yet still gives you plenty of techniques and ideas for creating your own work.

My suggestion is for you to take what moves you from the lessons and make it your own. Some steps you may totally leave out; others you may develop more deeply. Trust your gut and listen to your intuition when creating. This is what intuitive painting is all about, and with my years of practice it's certainly become my favorite way to create.

You may want to practice a bit in your sketchbook (I suggest one with thick paper that can take a variety of water-based media) to practice on before moving onto nicer surfaces. You must put in the time and allow yourself to play for hours upon hours. This will help you develop your own personal style, and it will become stronger with time and practice. From the time you spend while painting you will suddenly become comfortable and inspired by your own aesthetic and style.

So look to the corresponding lessons to awaken the muse within you at the beginning of each month. Take in my examples and those of the other participating artists. Notice what ignites you visually, what stirs that longing to create. Pay attention to that because it's important. It may be certain color combinations or use of line; it may be the implied texture in a work or the use of pattern. Certainly don't feel bad if you want to mimic a work you see—you will still make it your own and your style will grow stronger with time.

If you are an experienced painter, allow this book to get you to try new things within your own style. My experience is that it can only deepen a portfolio and add to your creative toolbox.

Sign up for our free newsletter at CreateMixedMedia.com.

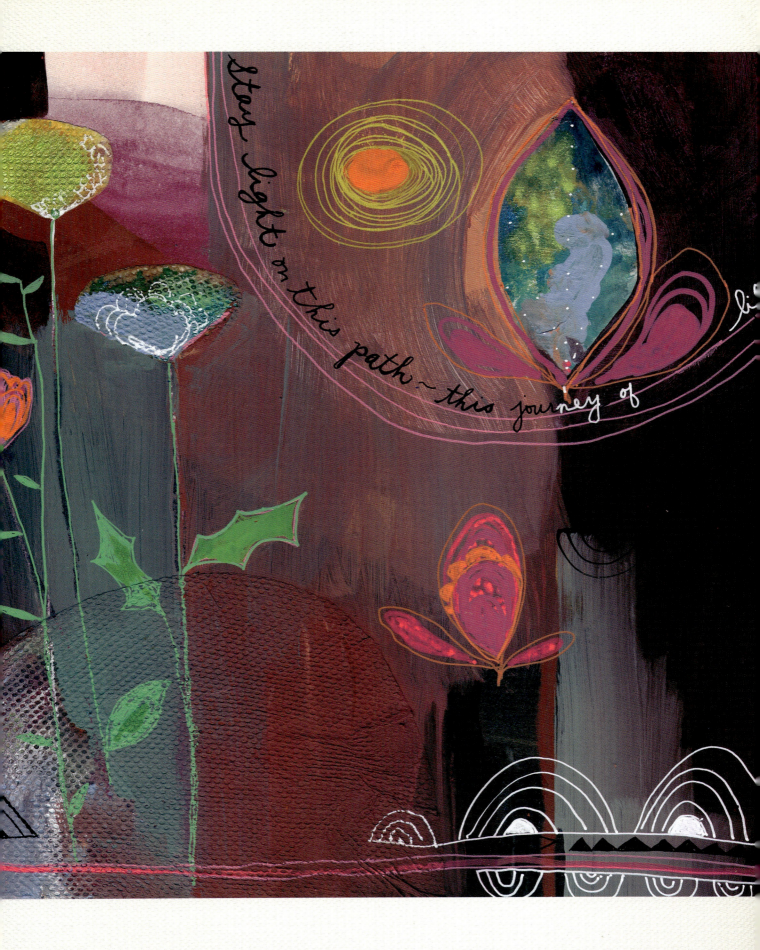

For additional downloads from the book, go to: CreateMixedMedia.com/IntuitivePaintingWorkshop.

9

Comparison is the thief of joy.
–Theodore Roosevelt

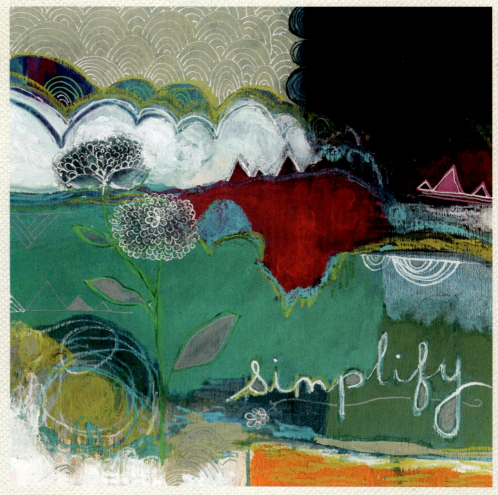

The above is one of my favorite quotes to share with my students in my online classes. Every so often I will hear from students that they are feeling bad about their work because it simply does not look like the others.

This is certainly part of the human experience, one in which we can all relate to in some way. The valuable lesson, or practice, is to not compare yourself to others (others may have been painting for years on end) and to be OK just where you are as an artist.

What I have noticed from working with hundreds of folks online is that it is only by doing the work that we grow. So let your critical mind step aside when working with this book, and allow the gift of the beginner's mind to be your greatest asset.

This can be true for those who have painted for years but are ready to shift their work in new directions. Allow painting time to truly be time for yourself. See what it's like to create without judgment, to create without comparing yourself to others, to create purely for the joy of the act of creation itself.

With all of these practices, witness how your work transforms. Allow it to blossom with grace and acceptance, by loving what you do and how you do it. I feel that whatever state we find ourselves in, whether peaceful, upset, frustrated or content, our paintings reflect that. That is the beauty of our work: It serves as a mirror and as a place of discovery.

All emotions are just fine to put into your art. Just allow yourself to move freely though the process. Stay less in the analytical mind and more in kinesthetic learning and silent noticing. Again, learn to feel into the painting and be delighted by the journey.

With a beginner's mind we have infinite possibilities and a new world lies ahead, but you must take the time (and I mean a good deal of time) to do the work. The joy, the discovery, the possibilities, the learning (and un-learning) happen by witnessing, becoming inspired and devoting hours of art time for yourself.

Another mission of this book is to connect you to the seasonal wheel, the cycles of the Earth and the rhythms and expressions of Nature in each of the four seasons. I find it pure and true to look to the natural world for inspiration because it's such a reflection of who we are as human beings.

I know for myself how affected I am by the weather. Perhaps when we are in tune with the time of year we are in, how it affects our surroundings and how nature creates an infinite amount of color, forms, shapes and patterns, we can be more authentic in our art-making.

Or perhaps this book is just another way to keep you actively painting and inspired throughout the year; to see painting as another way of keeping a diary, or collecting feelings and experiences.

In this book you will also find four seasonal check-ins—places to encourage you to draw, doodle and write down your thoughts in your journal or sketchbook.

Suggested Materials

This list includes the materials I used to create the paintings in this book, but it is merely a suggestion. You can certainly use more materials than these, and perhaps will have your own favorites not included here.

Experiment with a variety of surfaces to paint on. I love Aquabords, any size. Alternatives to Aquabords include wood panel (birch, pine or light-colored wood), watercolor board, thick watercolor paper and Gessobord. I also like to work on canvas and pressed cardboard.

Acrylic and India inks

Acrylic paint

Acrylic spray paint

Brushes

Decorative papers

Extra-fine glitter

Gel pens

Gesso

Gloss or matte medium

Pencils

Sketchbook

Spray varnish

Stencils

Surfaces

Water-based paint pens

Water-based wax crayons

Watercolor pencils

White eraser

Acrylic and India Inks
Buy at least six colors in a range of hues. You may want to get a few pearlescent ones, too. I like Liquitex brand, FW Artists Ink and Dr. Ph. Martin's Bombay Inks.

Brushes
Choose a few small flat and round ones along with medium flat and round brushes, mop brushes and angled ones. With brushes, variety is always helpful. I tend to not buy expensive brushes because I go through so many of them. Brushes for acrylic and/or watercolor paint are best. Get a set of foam brushes, too.

Decorative Papers

Work from a variety of papers and images. Papers with a hand-made feel are best (ones without a plastic covering and soft to the touch). I also love origami paper!

Paint

Choose at least six colors plus a few bright fluorescents, neutrals, black and white. I like the Golden brand and Blick Matte Acrylics.

Gel Pens

Choose a few sparkly gel pens. I like Sakura Gelly Roll pens best.

Water-Based Paint Pens

Several extra-fine, fine or medium point pens will serve you well. I avoid regular markers and oil-based paint pens. Uni-Posca paint pens from Japan are my favorite. I also fancy the fluorescent colors (large tip).

Water-Based Wax Crayons

My absolute favroite: Caran d'Ache Neocolor II Artists' Crayons.

For additional downloads from the book, go to: CreateMixedMedia.com/IntuitivePaintingWorkshop.

13

Art Terms

Here are just some of the art terms that might be helpful for you to familiarize yourself with when painting.

Achromatic

In achromatic artworks there are tones of black only. A gray scale is considered achromatic because it lacks hue and cannot be classified into the primary colors of red, blue and yellow.

Balance

Balance is the way that lines, shapes, colors, textures or space are successfully arranged in a work of art. The elements can be uneven or asymmetrical. In contrast, the work can be symmetrical, where there is equal weight on both sides of the work. Balance occurs when the overall harmony of the piece exists.

Brushes

Brushes vary with the type of paint they are made for, the substrate to which the paint is applied as well as the desired effect. A general look at the types of brushes available:

Bright—Flat and short hairs with inwardly curved edges toward the tip. Great for short controlled strokes and thick heavy color. Helps when working up close to the canvas.

Flat—Square end with medium to long hairs, good for bold strokes, washes, filling a wide area, straight edges and stripes. Longhaired flats are good for varnishing.

Fan—Can be considered a part of the flats. Natural hairs are good for smoothing, blending and feathering; synthetic hairs work well for textural effects.

Filberts—Flat and oval shaped with medium to long hairs.

Longs—Also a part of the flat, square-edge style, with long sable hairs or bristles.

Round and Pointed Round—Good for sketching, outlining, details, delicate areas and retouching; the detailers generally have shorter handles.

Collage

A collage, French for "to glue", is artwork made with different elements, such as pictures, papers, found objects or cloth.

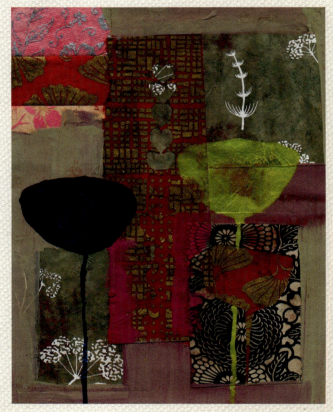

Sign up for our free newsletter at CreateMixedMedia.com.

Color

Color is what hue the eye sees when light reflects off an object. An artist's traditional color wheel has twelve colors: three primary (red, yellow and blue), three secondary (orange, purple and green) and six tertiary (red-orange, yellow-orange, yellow-green and so on).

Color Theory

The principle "color is light" is the basis of color theory. The pigment of an object will reflect the colors in light that are seen and absorb all unseen color. White is a color where the pigment is stimulated by light that reflects all color subsets to the human eye. An all-white visual stimulation will be void of hue and grayness and, like the tones of black, is not found on a color wheel.

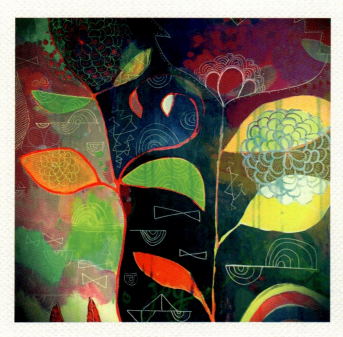

Complementary Colors

These colors are found on opposite sides on the color wheel. The primary colors are red, yellow and blue, and the secondary colors are orange, purple and green. These pairs (red/green, orange/blue and yellow/purple) complement or enhance each other.

Composition

A composition is the combination of parts or elements (as lines, colors, objects) arranged to form a whole.

Contrast

Contrast refers to objects, colors or textures used in artwork that are visually opposite and enhance or intensify each of their properties and the image as a whole.

Dominance

The object, shape or color in a work of art that holds the most influence to the whole image is said to have dominance.

Dry Brushing

An application technique for painting that uses less water than pigment.

Elements of Art

These elements consist of the visual symbols or building blocks used to make a work of art and can include line, shape, form, space, color (value, hue, intensity) and texture.

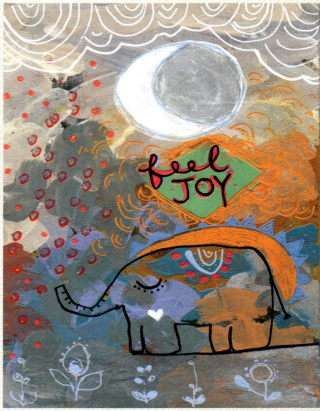

For additional downloads from the book, go to: CreateMixedMedia.com/IntuitivePaintingWorkshop.

15

Emphasis

An emphasis is the focal point in a work of art.

Fixative Spray

This substance is sprayed on a drawing to prevent blurring as used over charcoal or pastels.

Form

As an artistic element, as in a sculpture having three dimensions, form is the manner or style of arranging and coordinating parts in a work of art for a pleasing or effective result.

Harmony

Successful use of the elements of art, when working together, can produce a feeling of harmony in a work.

Highlight

A highlight in a painting conveys light reflecting off an object and is usually small.

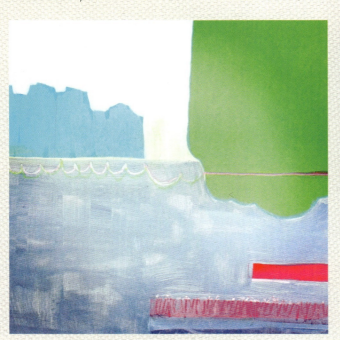

Hue

Hue is the color reflected off an object as perceived by the human eye and is categorized on a color wheel.

Intensity

This refers to whether a color is low intensity and has neutral, soft or dull tones, or high intensity and has bright, pure or undiluted tones.

Line

A line is a mark or stroke made longer in proportion than its height or width.

Medium

A medium is any substance used in producing a work of art: stone, wire, clay, paint, ink, gesso, substrates and film. *Media* can be used to imply more than one medium, but *mediums* is acceptable also.

Movement

When the elements in a work of art help to create a feeling of motion, it is said to have movement, or that which causes the viewer's eyes to move around a painting.

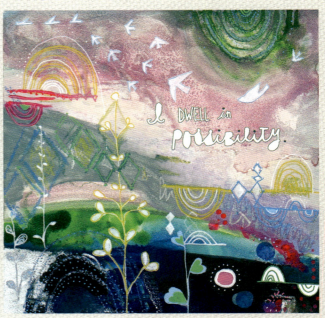

Organic

Free-form or free-flowing and curving shapes—those that would grow or occur in nature—are considered organic and are typically not squared off or angular.

Pattern

Pattern in art is created by repeating colors, shapes and lines to form motifs in a painting.

Perspective

Perspective is a linear and mathematical way of relaying the visual concept of a three-dimensional space on a two-dimensional object, as on paper or in a painting. It employs mathematical concepts like the horizon line and vanishing point. Images in the foreground are larger, have more detail and appear closer.

Pigment

A pigment is a physical material used to create color in paint. It can be of natural or synthetic origin and is mixed with a binder. During the Renaissance, pigments were all made from natural sources such as ground red clay mixed with egg yolk (a binder) to make red paint. Pigments have different covering properties; some are transparent and some opaque.

Primary Colors

The three primary colors are red, yellow and blue and cannot be created by mixing colors.

Principles of Art

Guidelines, rules or familiar tools that an artist can use to organize a work of art are called "principles." The main principles include movement, unity, harmony, variety, balance, rhythm, emphasis, contrast, proportion and pattern.

Proportion

Proportion refers to size relationships within a painting or how one element relates to the whole.

Repetition

Repetition is a technique where creative objects are repeated in an artwork in order to highlight certain aspects of each, create intensity or appear minimal and move the observer's eye around the artwork.

Rhythm

Rhythm is a pattern in an artwork that is conveyed with variations, like rolling hills, stars in a sky or waves on a beach.

Secondary Colors

Green, orange and violet are the secondary colors made by combining the three primary colors. The secondary colors are midway between the primary colors on the color wheel.

Shape

A shape in art is an enclosed area created with line, texture or color. There are geometric shapes, such as circles, ovals, triangles and rectangles, and organic shapes, which are free-form in appearance.

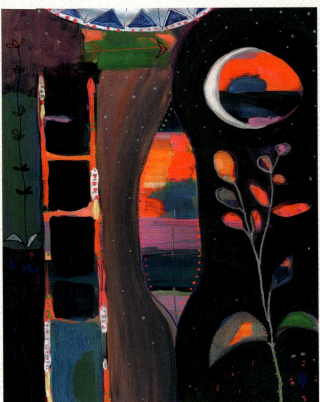

Space

Space refers to areas between and around objects, or it can also refer to a feeling of depth in a work.

Stencil

Stencils are transferred images, shapes or patterns. The object (paper, metal, plastic or cardboard) has a shape, image or design cut out of it. The cutout shape (stencil) is then used as a template to guide the paint through the opening onto the underlying surface.

Symbol

In art, a symbol is a picture, animal, plant or object of something recognizable that expresses or symbolizes an idea or a story.

Symmetry

In art, symmetry is when all the elements within a work of art balance each other with a sense of order and proportion.

Tertiary Colors

When you mix a primary color with its nearest secondary color on a color wheel, you will get six tertiary colors, often called "the grandchildren" of secondary and primary colors.

Texture

The actual tactile feeling of the surface of an artwork that also adds a dimensional look to the piece is called "texture." Texture can also be implied in a work to look as if it's real texture by the way a work is painted.

Tint

A tint is a color that has had white mixed with it to make it lighter. Pink is a tint of red.

Underpainting

The underpainting is where the first layer of paint, either in monochrome or in multicolors, is employed to provide a base for a painting and help define its color values.

Unity

Unity occurs when all combined elements in a work of art come together to make a complete, harmonious whole that is visually pleasing.

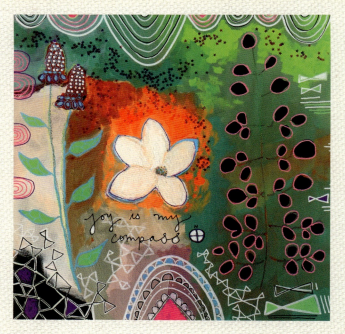

Variety

When combinations of the elements of art create complexity and intricacy, it is said to have variety, which increases visual interest in a work.

Wash

A wash is the fluid, semitransparent application of color to a painting. A wash uses water to dilute acrylics, inks or watercolor paints. With oil paints, a solvent like mineral spirits or turpentine is used.

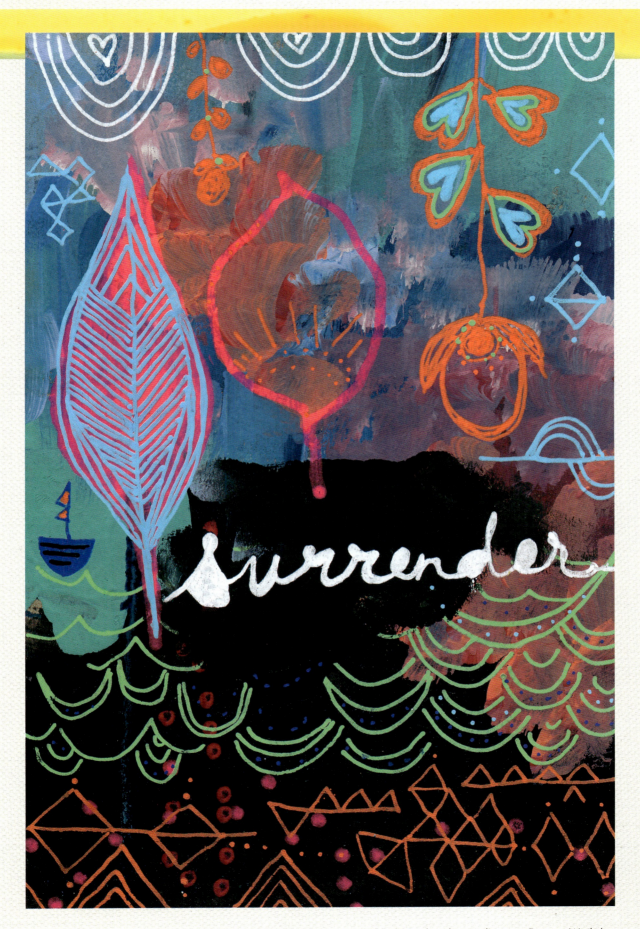

For additional downloads from the book, go to: CreateMixedMedia.com/IntuitivePaintingWorkshop.

19

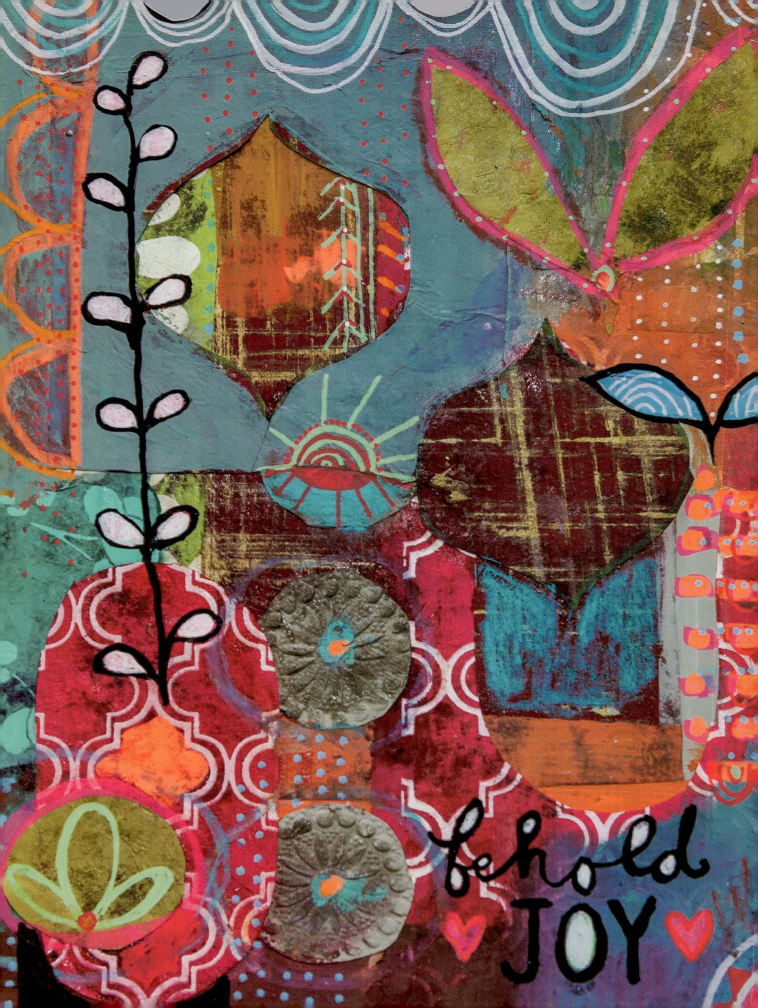

January

We will open the book. Its pages are blank. We are going to put words on them ourselves. The book is called Opportunity and its first chapter is New Year's Day.
–Edith Lovejoy Pierce

Start the new year off with some bright and alive intentions made through painting! Create a mixed-media work that uses layers of paper and paint in an intuitive and freeing process. Learn to incorporate script into your work that holds a word or phrase for an intention for this new year. This is a super fun (and addicting) lesson that can teach you the value of layering, using paper with painting and drawing out a positive affirmation for your life. Allow your inner critic to step aside in this lesson and allow the artist child within you to come out and play!

Step-by-Step Demo:
Paint, Paper & Script Intentions

What You Need

Acrylic paint
warm (reds, oranges, yellows)
cool (blues, lavenders, greens)
black, white and neutral colors (grays, beiges)

Clear spray varnish

Decorative papers
non-coated with a soft or handmade feel

Matte or gloss medium

Paintbrushes
for acrylic painting

Scissors

Smock

Surface
canvas board, wood panel, Gessobord or even pressed cardboard will do; you can also try this lesson on thick watercolor paper

Water cup

Water-based paint pens
and/or Neocolor II Artists' Crayons

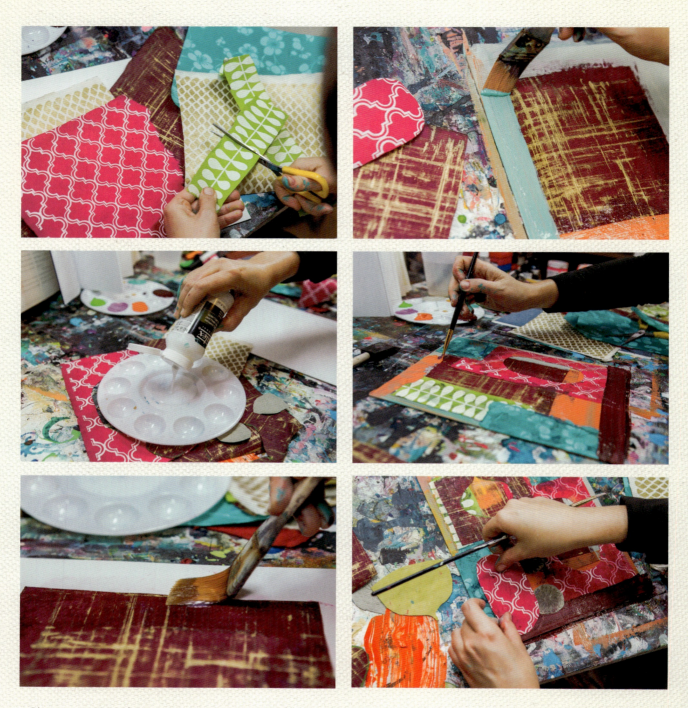

1. Choose an array of decorative papers you wish to collage with, ones with bold and bright colors that also contrast and harmonize with one another. Begin to draw and cut out shapes in a variety of sizes. Keep the inverse of your cutouts as you might want to use those, too.

Squeeze some matte or gloss medium onto your palette. Begin to adhere the pieces of cutout paper to your surface. Apply the paper with a flat brush with the sticky medium. Lay a thin coat on the bottom and top of each cutout piece of paper. Layer the papers in a rich and ornate fashion.

2. Begin painting over areas of the paper with acrylic paint. Use colors that blend and contrast: Experiment with pastels, bright or bold colors and neutrals, like grays and beiges.

Layer additional paper shapes in areas you feel need them. Accentuate and repeat shapes. Practice the law of wabi-sabi, or the acceptance of imperfection. Some concepts of wabi-sabi include asymmetry, irregularity and simplicity. This creates contrast and balance.

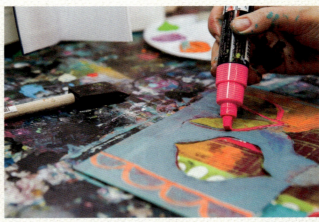
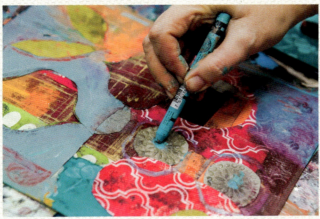
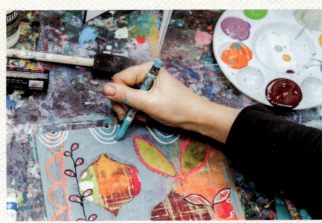
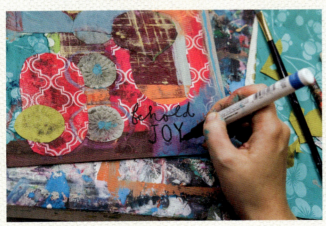
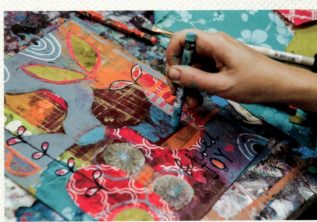

3. Repeat this process for a while and when the painting is dry, add decorative drawn details with your water-based paint pens and water-soluble artists' crayons (which can work fine with inks and acrylics).

When the painting is feeling complete, add your word or small phrase for your intention of the year. I often use black for this. See the word as an artistic element in the work, one that blends and harmonizes, one that is "drawn out" instead of "written."

4. I love to fill in portions of some of my letters with color. You may want to practice with pencil on the painting until you feel comfortable with writing out script. Add any finishing details with the pens or crayons or even acrylic paint.

Once the painting is fully dry, seal or spray it with a final coat of varnish.

For additional downloads from the book, go to: CreateMixedMedia.com/IntuitivePaintingWorkshop.

23

More Inspiration

A Gallery to Get You Painting!

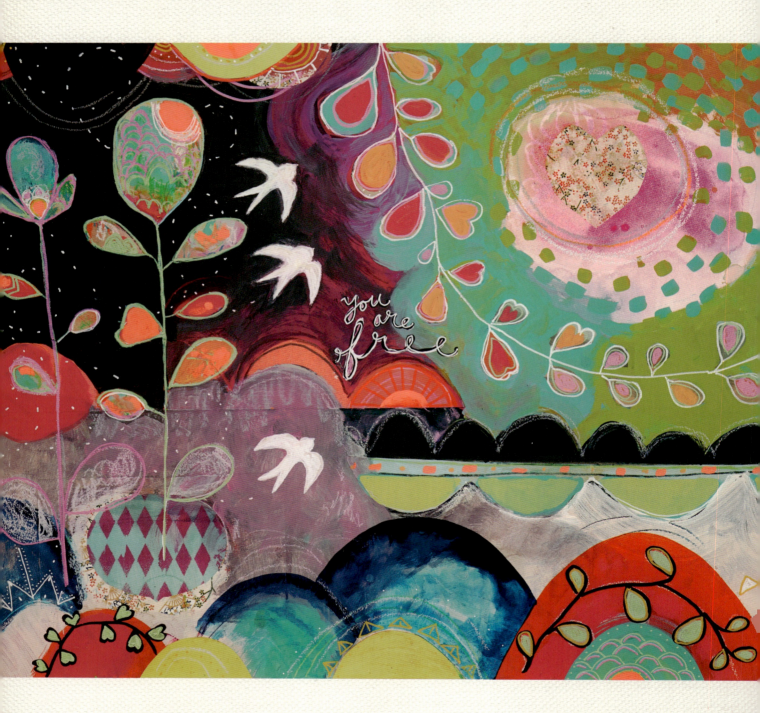

Sign up for our free newsletter at CreateMixedMedia.com.

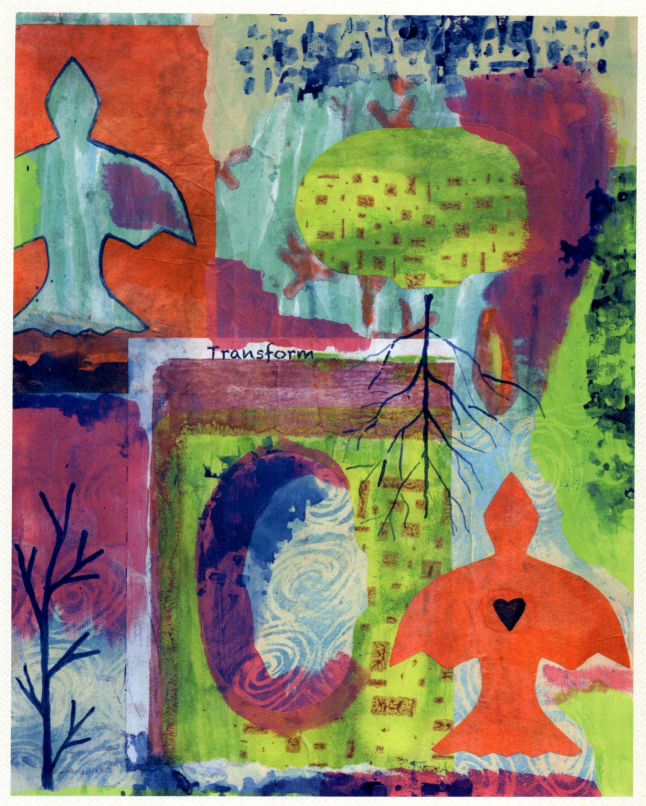

Mae Birch

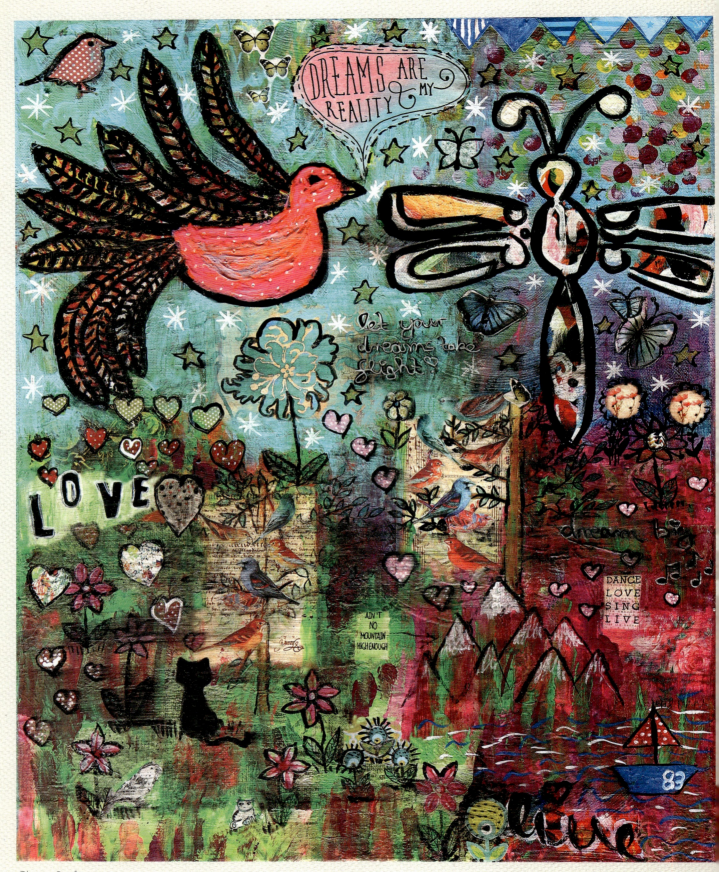

Chrissy Seufert

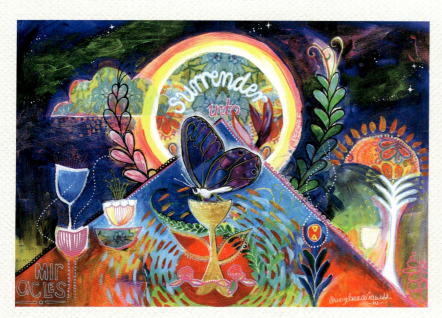

Chrissy Foreman Cranitch

Esther Orloff

Emily Ankeney

Amanda Jennings

For additional downloads from the book, go to: CreateMixedMedia.com/IntuitivePaintingWorkshop.

27

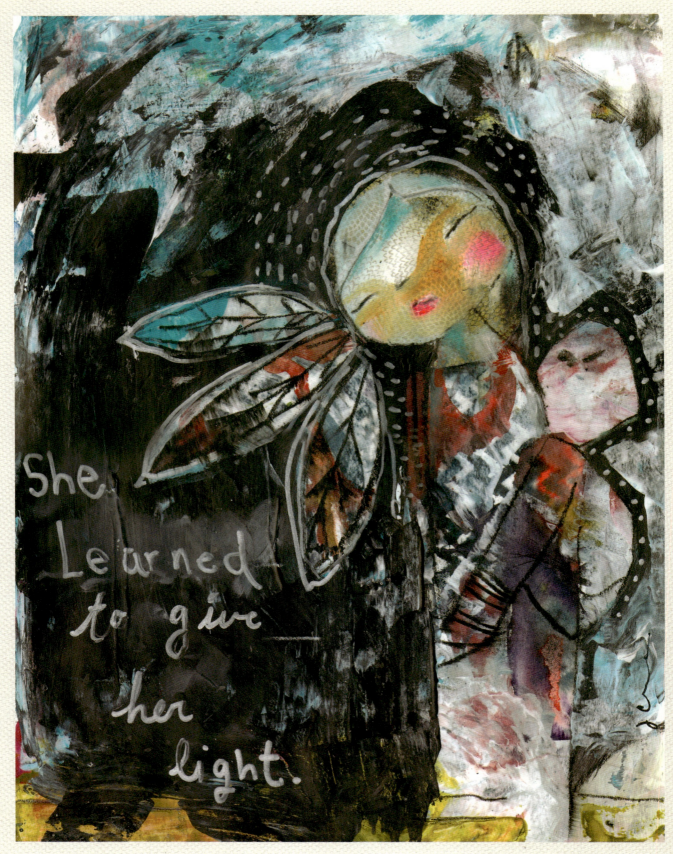

She
Learned
to give
her
light.

Juliette Crane

Sign up for our free newsletter at CreateMixedMedia.com.

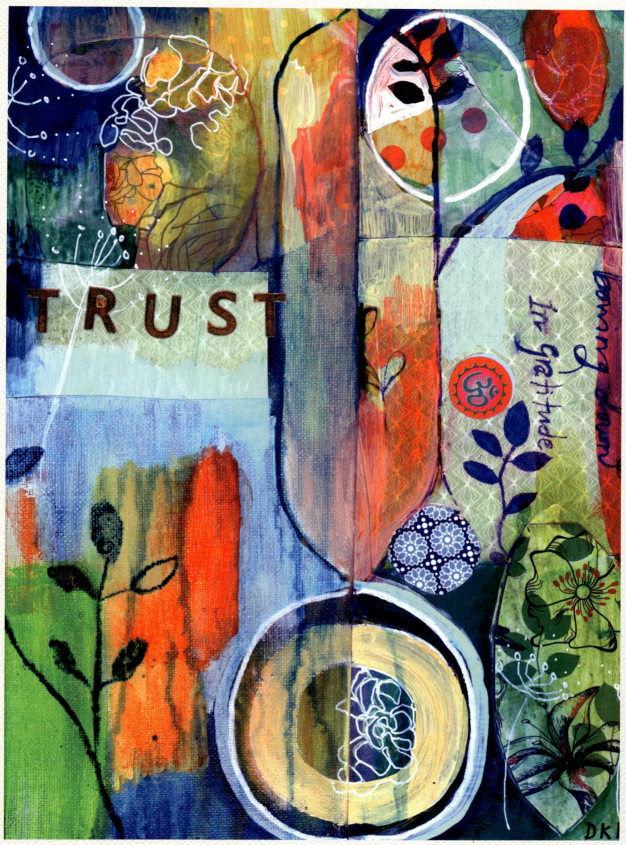

Julia Godden

For additional downloads from the book, go to: CreateMixedMedia.com/IntuitivePaintingWorkshop.

29

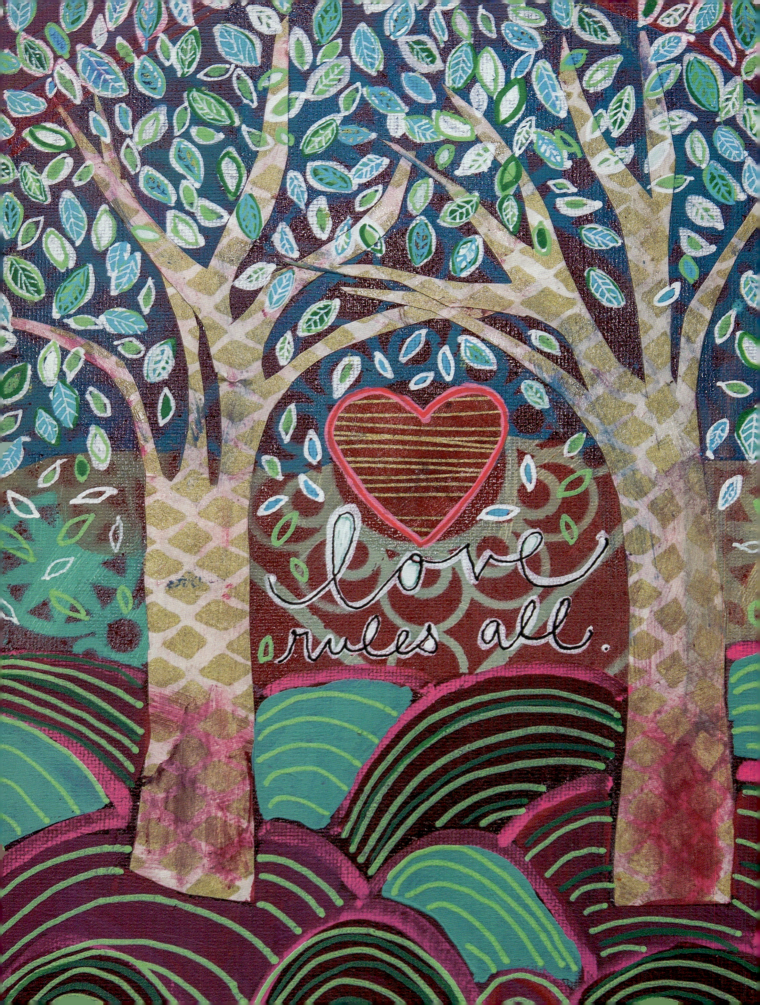

February

Love is, above all, the gift of oneself.
—Jean Anouilh

Honor those you cherish by creating a simple and elegant painting that is all about the L word: LOVE. Work in rich colors, sweeping movements and sweet narratives or subject matter that gives thanks to those you care for the most. As an option, you can also add some other media if you wish, such as paper, and learn to incorporate stencils. This project makes a wonderful gift to give to that special someone in your life, just in time for Valentine's Day or as a reminder for yourself to keep loving your own being as much as you can, for that is the greatest gift of all.

Step-by-Step Demo: **Loving Expressions**

What You Need

Acrylic paint
variety of warm and cool colors
gesso (optional)

Acrylic spray paint

Clear spray varnish

Decorative papers
non-coated with a soft or handmade feel

Matte or gloss medium

Paintbrushes
for acrylic painting

Scissors

Smock

Stencil
large if possible

Surface
canvas board, wood panel, Gessobord, thick watercolor paper, etc.; I used a light wood panel

Water cup

Water-based paint pens
and/or Neocolor II Artists' Crayons

For additional downloads from the book, go to: CreateMixedMedia.com/IntuitivePaintingWorkshop.

31

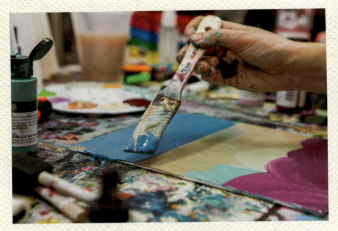
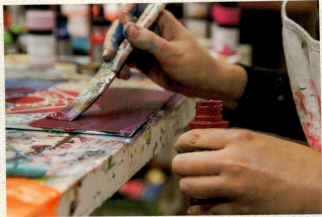
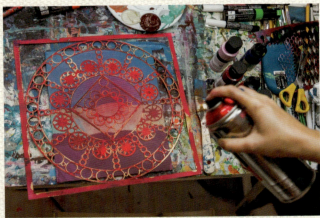
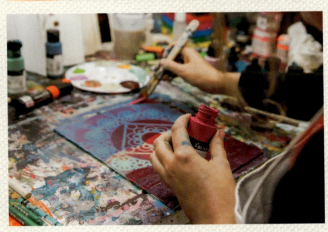
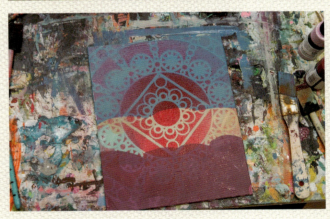
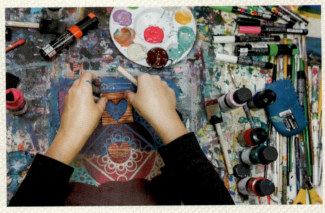

1. Paint the base of the wood panel with gesso or straight with acrylic paint as I did. If you use straight acrylics, some wood grain will show through. Choose several colors to paint your background with. Using a flat brush always works well when painting on a flat surface. Paint slowly and layer colors over one another. Let the panel dry.

Once the background is dry, lay a stencil over the substrate. Take your spray paint and lightly spray all over the stencil in a quick and even fashion—about 8" (20cm) away or as directed on the can. Lift up the stencil when finished spraying and let the paint dry before going further.

2. Begin to paint over the stencilled area with acrylics. Blend in similar or analogous colors (blues, blue-greens, greens) or add some contrast and strong vibration with complementary colors (e.g., purple and yellow).

Cut out a few shapes at this point if you like. Hearts are easy to cut out and make a fitting addition to a Valentine's painting.

Begin to envision how you would like the painting to move forward, now that you have created a strong background. Would you like this painting to feel more abstract or have some subject or narrative (story) to it? Make a decision and sketch out some ideas if you need to for your composition.

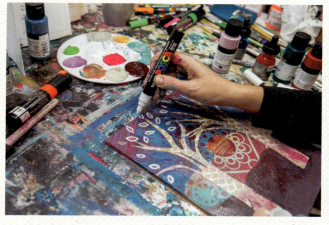
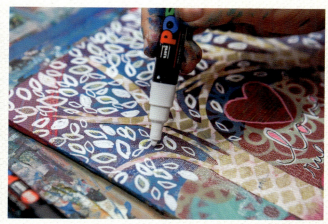
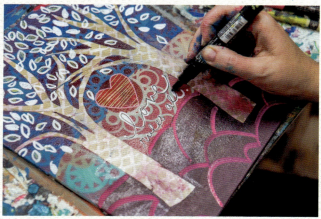
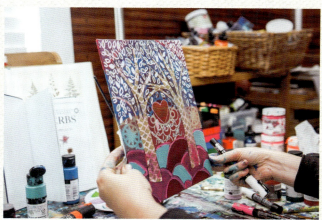
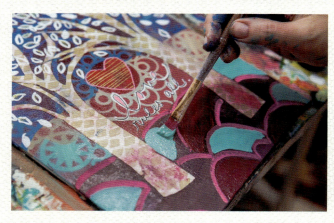
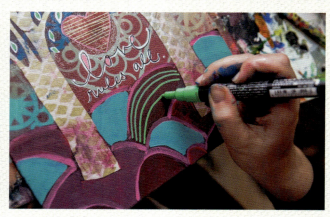

3. I also cut out a few tree trunks here in my example. I used paper from the East that I found at a popular paper store.

Using a foam or flat brush, thinly coat the back of your cut-outs with gloss or matte medium. Press the paper evenly and firmly to your painting. Finish it off by coating another thin layer of medium on top.

Once the work is dry, continue to refine and add more whimsical details to your work. Use the paint pens (both fine and medium point) to add a message of love to your work.

4. Paint in more areas with acrylic paint to give the work even more color and dynamism.

Finish off the painting by adding more details with the paint pens (it's always good to step away for a while and then revisit your work with fresh eyes). Seal the painting with a liquid or spray varnish once you are finished.

For additional downloads from the book, go to: CreateMixedMedia.com/IntuitivePaintingWorkshop.

More Inspiration

A Gallery to Get You Painting!

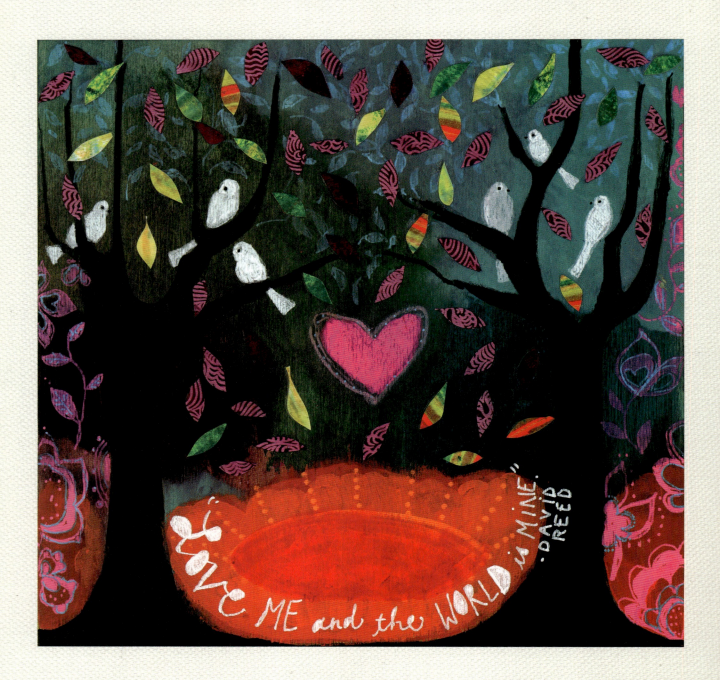

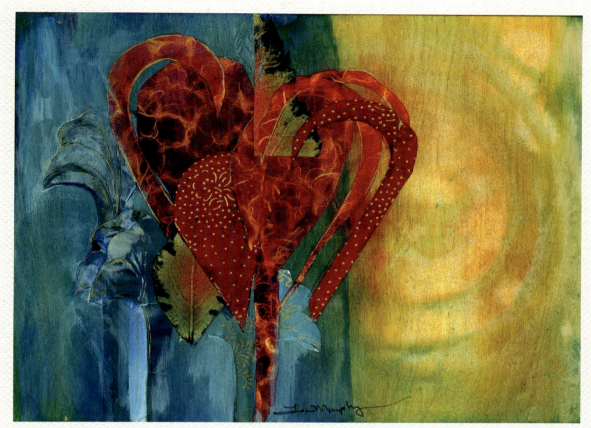

Lisa Murphy

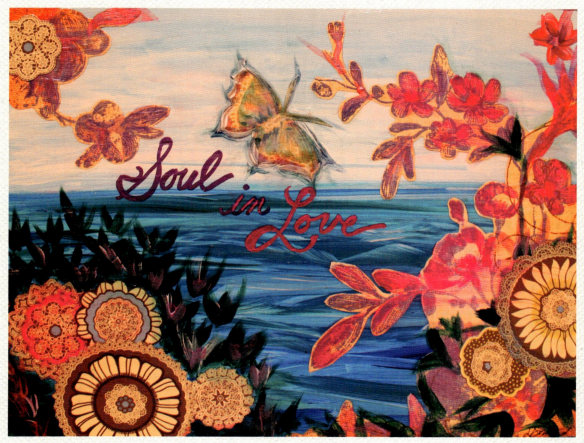

Laura Soranno

For additional downloads from the book, go to: CreateMixedMedia.com/IntuitivePaintingWorkshop.

35

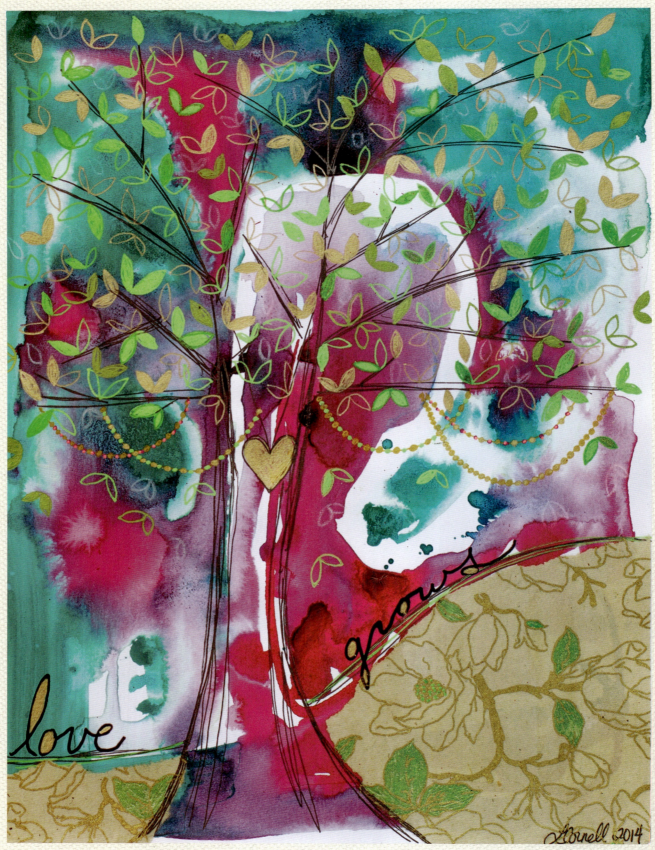

Lara Cornell

Sign up for our free newsletter at CreateMixedMedia.com.

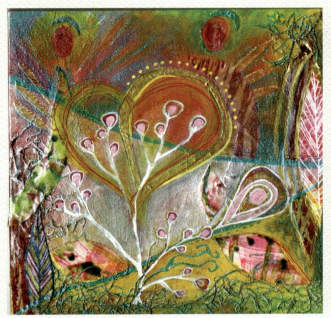

Sarah Nakatsuka

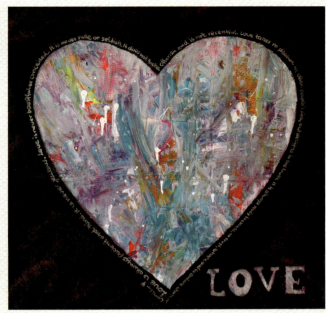

Chrissy Seufert

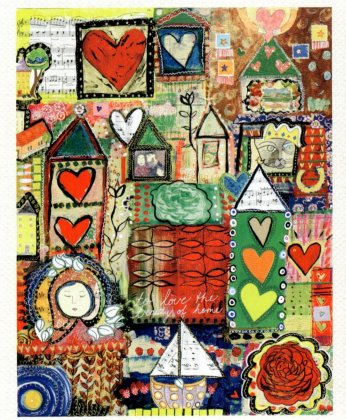

Rebecca Kim

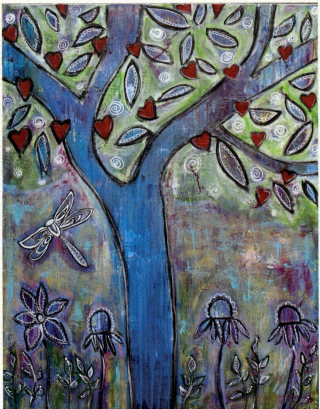

Karin Tintle

For additional downloads from the book, go to: CreateMixedMedia.com/IntuitivePaintingWorkshop.

37

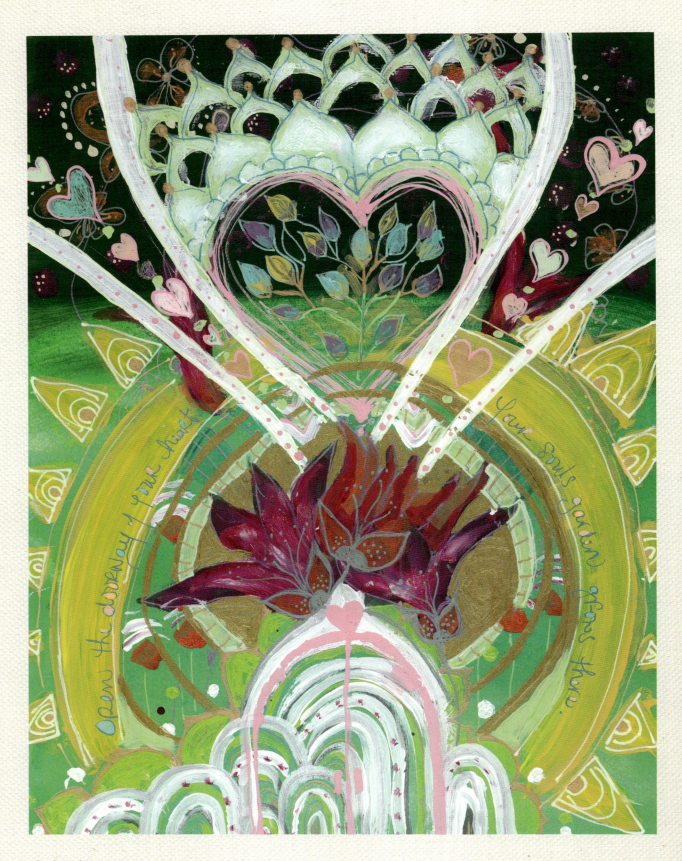

Kimberly Leslie

Spring Check-In

It was one of those March days when the sun shines hot and the wind blows cold: when it is summer in the light, and winter in the shade.
—Charles Dickens

Spring is all about celebrating that which has been dormant coming alive again. It speaks to us of fertility, new growth and bright fresh color. It is a swirling dance of delicate blossoms falling on the sidewalk. It is the once-again happy sound of birdsong delighting our ears in the late afternoon.

Journaling Prompts

- In what ways can you allow your art and creativity to blossom more this spring?
- How do you see your painting practice already beginning to shift and grow? What do you like about it? What do you wish to change?
- What elements of spring do you wish to include in your painting? (Examples can be new pink blossoms on trees, butterflies and bumblebees buzzing, more light and brighter hues, and so forth.)

Practice doodling some of your favorite spring flowers.

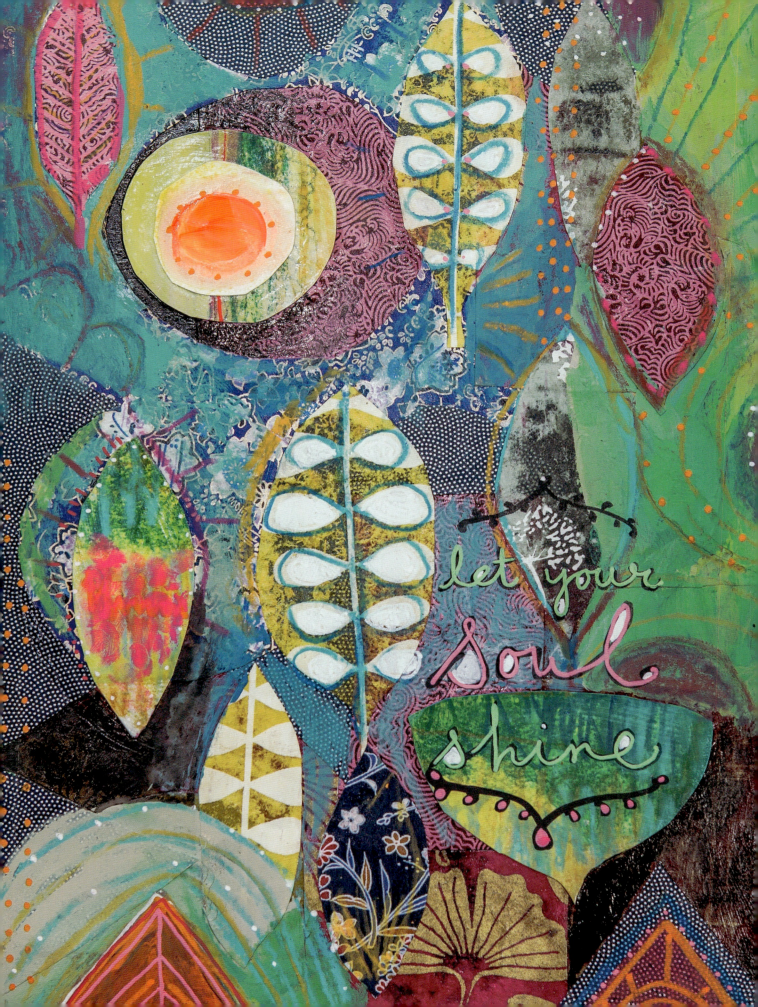

let your soul shine

March

Looking to your dream world and soul longing, create a layered collage that is heavy in pattern and ornate detail. Use symbols and vibrant colors to share your soul's story or to express your dreams. This is a painting focused heavily on collage work. (We will delve more into simply painting after this month.) This lesson is also perfect for the beginning artist, who can start simply by exploring the way shapes overlay and colors intermingle to create a composition. The experienced artist will also enjoy this lesson for it allows us to "paint" with paper—not something commonly done by painters.

Step-by-Step Demo: **Soul Collage**

What You Need

Acrylic paint
 colors that are symbolic to you
 gesso (optional)

Clear spray varnish

Decorative papers
 non-coated with a soft or handmade feel

Gloss medium

Inks
 acrylic ink or India ink

Paintbrushes
 for acrylic painting and foam brushes for collaging papers

Pencil

Scissors

Smock

Surface
 canvas board, wood panel or Gessoboard

Water cup

Water-based paint pens
 and/or Neocolor II Artists' Crayons

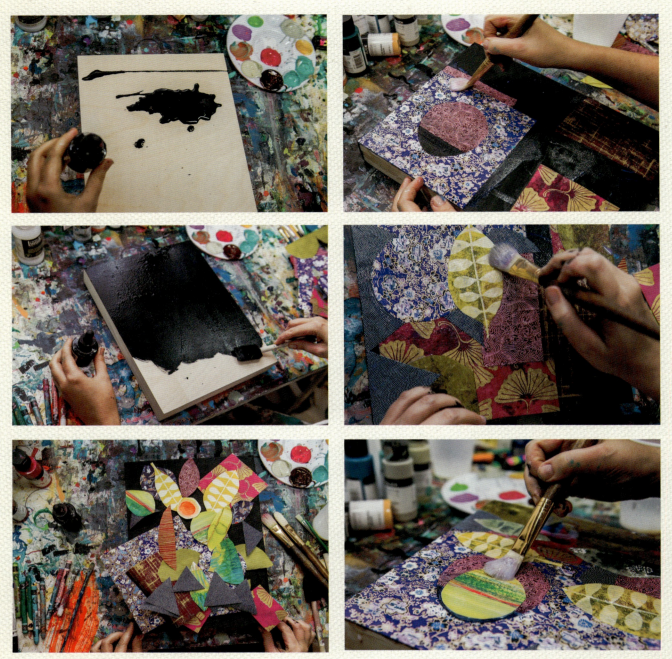

1. Paint the background of your surface. I like to use a dark or black color to begin with so all the colors of the papers stand out boldly against it. I used black acrylic ink on wood panel.

Pick out a variety of decorative papers you wish to layer with, ones with bold and bright colors that also contrast and harmonize with one another. Begin to draw and cut out shapes that represent your soul. Look to be inspired by rich patterns and ornate designs when choosing your paper.

2. Begin with the largest cutout pieces of paper and start adhering them to your surface. Apply the paper with gloss medium using a flat or foam brush. Lay a thin coat on the bottom and top of each cutout piece of paper. Layer the papers in a rich and ornate fashion. Have inverse shapes cut out so the layers of the paper below can show through.

You may also want to paint your own paper. Do this by painting with inks (or watercolors) and any water-based drawing media to create abstract designs. Cut out shapes from this paper once the paint is dry. Continue covering the entire surface with layered pieces of paper until it feels rich and full of color and pattern.

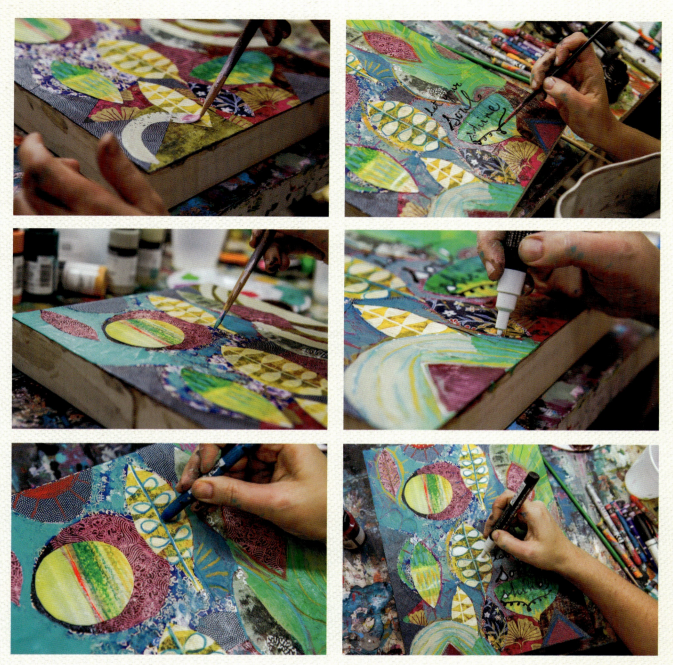

3. Begin to add paint to the surface to blend and highlight certain areas. For example, you may wish to paint around certain shapes to have them stand out more. Working with neutral acrylic paints helps the other bold colors in the paper to stand out. Cool colors (such as blues, lavenders and blue-greens) recede in a painting and provide a feeling of calm; warm colors (reds, oranges, yellows) come forth in a painting and give a sense of passion or energy.

Color in parts of your painting with water-soluble wax crayons. Blend and draw over the layers of paper to help unify the work.

4. Write a message to your soul with black ink and/or a black paint pen. You may want to practice your script in your sketchbook before drawing it out on your work. You can also draw your script with pencil on the painting first and then go over it with ink. Here I am using a small round brush that I am dipping into a black ink jar.

Add tiny details and refine or accentuate certain elements with paint pens. You can also fill in your letters with a different color (like I did with white) to have them stand as an artful element to the painting. Lightly spray the piece with varnish to seal it.

For additional downloads from the book, go to: CreateMixedMedia.com/IntuitivePaintingWorkshop.

43

More Inspiration

A Gallery to Get You Painting!

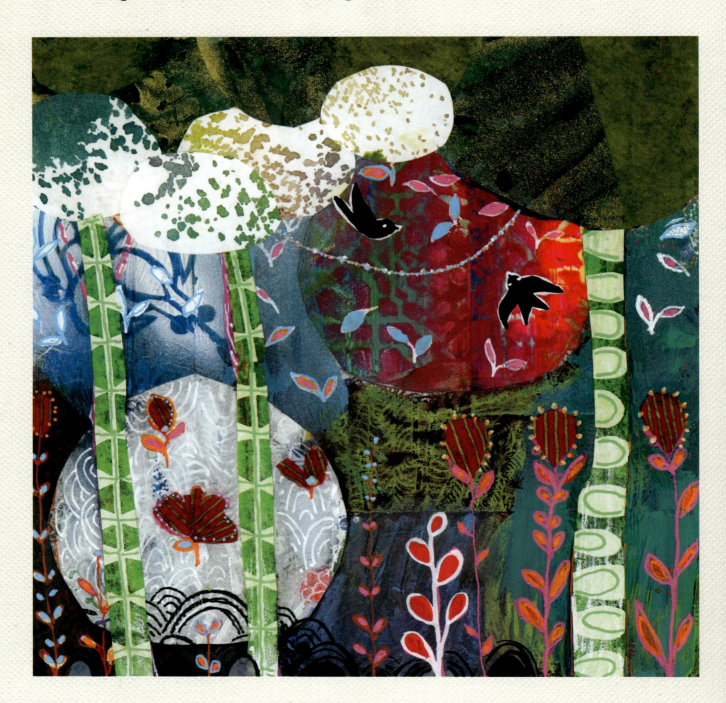

Sign up for our free newsletter at CreateMixedMedia.com.

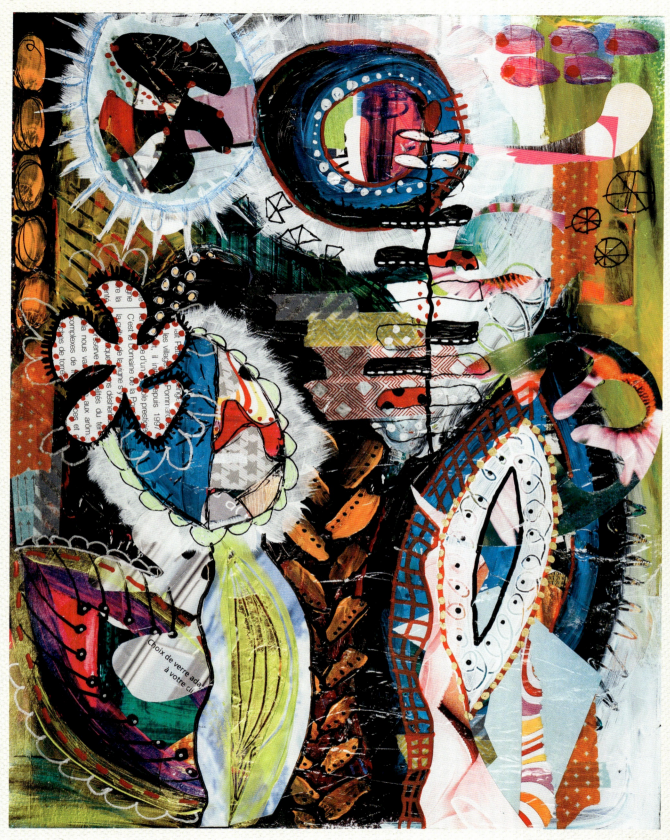

Marika Lemay

For additional downloads from the book, go to: CreateMixedMedia.com/IntuitivePaintingWorkshop.

45

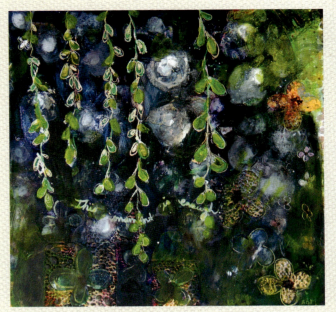

Michelle Blades

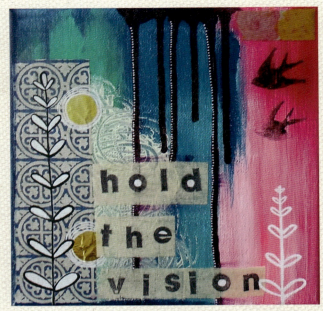

Sally Okkerse

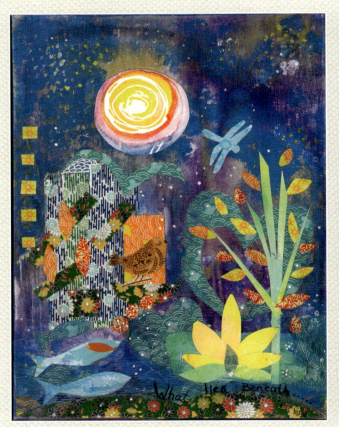

Barbara Buford

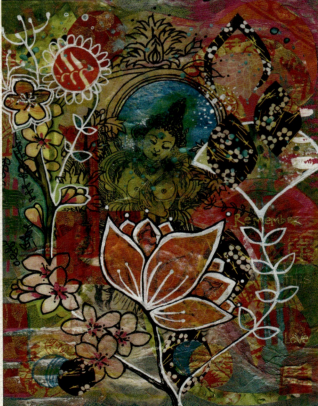

Sarah Nakatsuka

Sign up for our free newsletter at CreateMixedMedia.com.

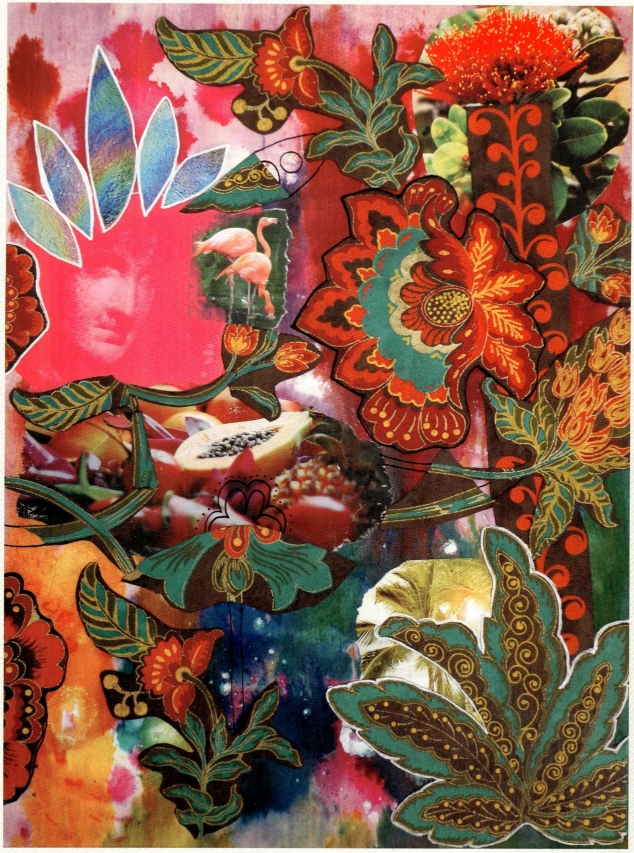

Cathrin Gressieker

For additional downloads from the book, go to: CreateMixedMedia.com/IntuitivePaintingWorkshop.

47

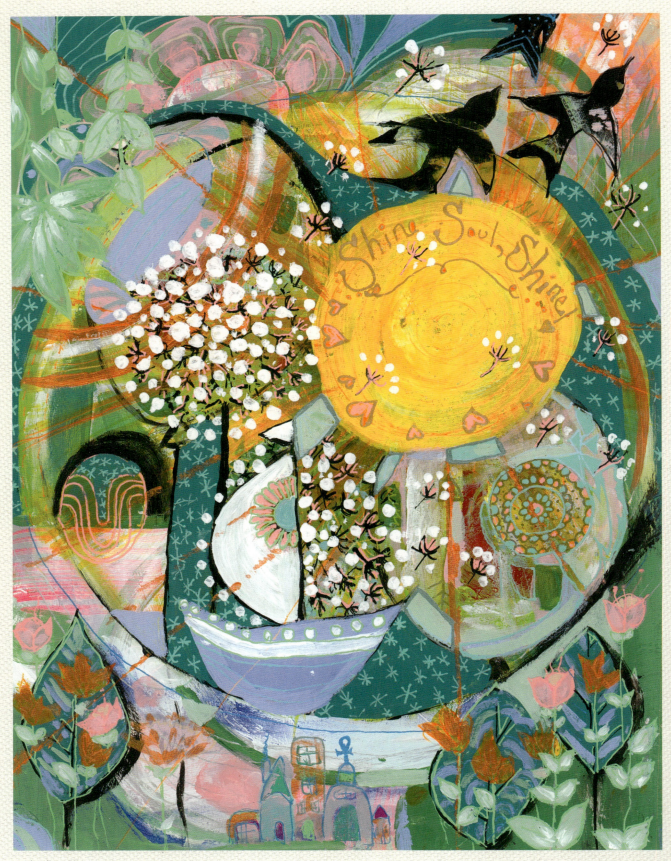

Kimberly Leslie

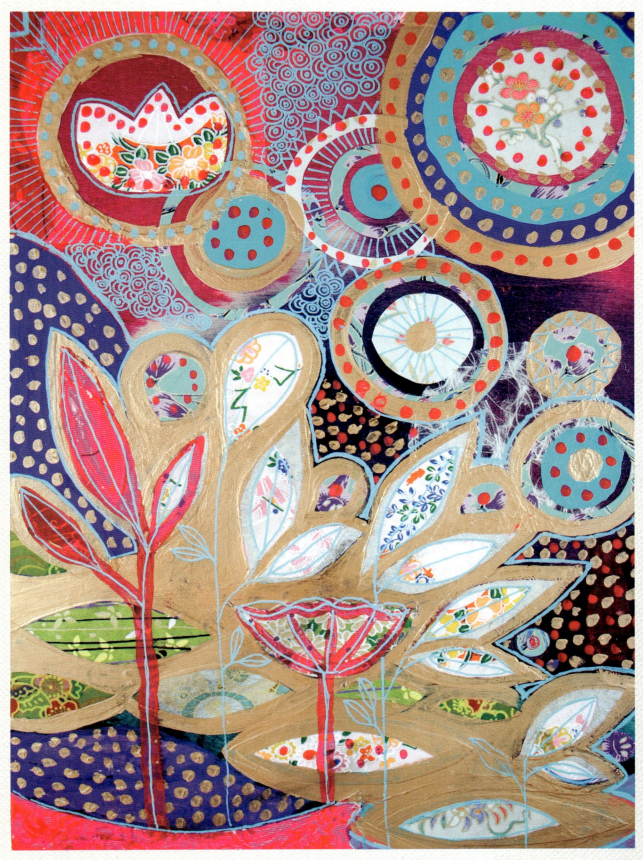

Lyn Metcalf

For additional downloads from the book, go to: CreateMixedMedia.com/IntuitivePaintingWorkshop.

49

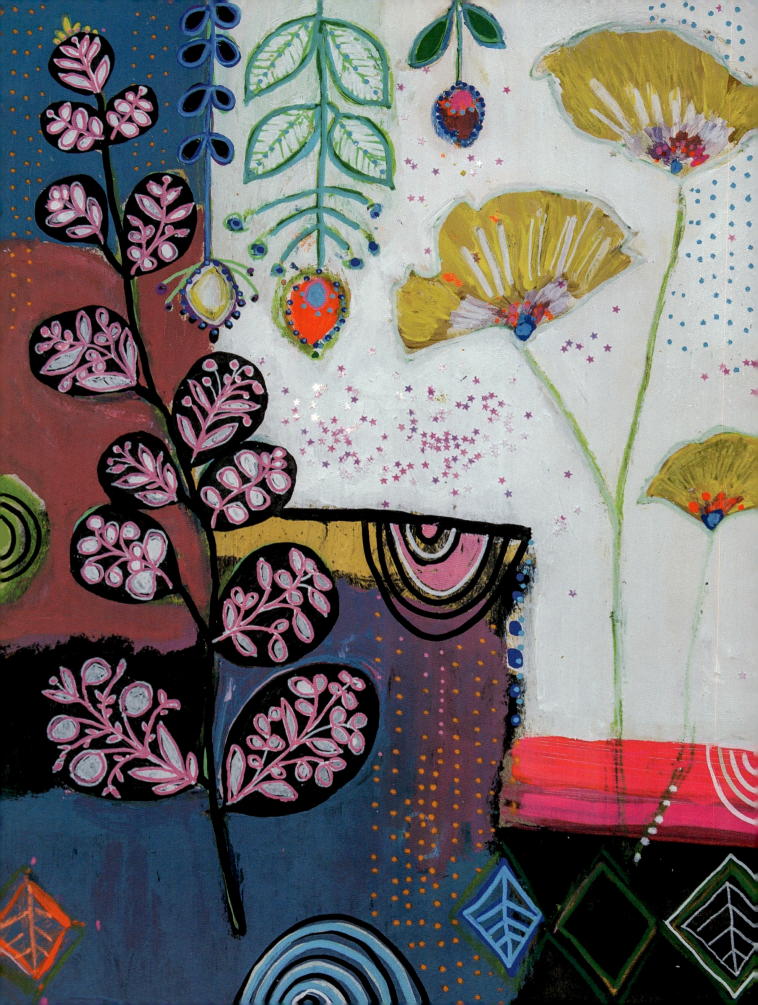

April

Freedom lies in being bold.
—Robert Frost

It's time to let loose as winter is coming to a close. Using bright contrasting colors, create a painting that is all about play. Glitter, geometric shapes, fluorescent colors that stand out against black, white and neutrals are just some of the themes for this month. Use plants and flowers to inspire you. Find reference material in picture books. Practice motifs in your sketchbook and remember to be patient with yourself! With time, your hand will naturally begin to be drawn to certain motifs that will eventually be seen in a more consistent manner in your work.

This lesson is all about being current with art trends and allowing the contrasting elements within the work to shine forth. Top the painting off with a touch of glitter to give it that extra sparkle.

Step-by-Step Demo: **Bright, Bold & Wild**

What You Need

Acrylic paint
bright colors you enjoy, including fluorescents and neutrals

Clear spray varnish

Extra-fine glitter

Inks
acrylic ink or India ink

Paintbrushes
for acrylic painting: round, flat and angled

Smock

Spray bottle filled with water

Surface
canvas board, wood panel or Gessobord, Aquabord or pressed cardboard

Water cup

Water-based paint pens
and/or Neocolor II Artists' Crayons

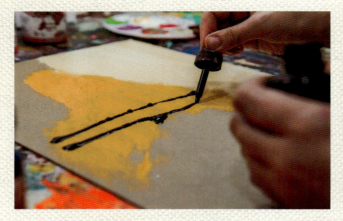

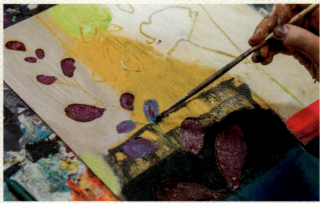

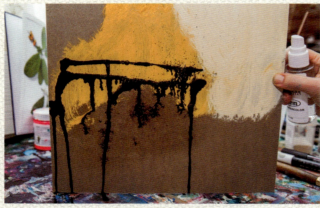

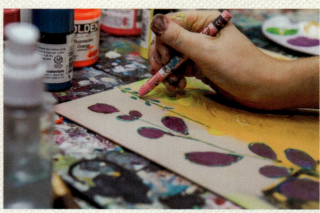

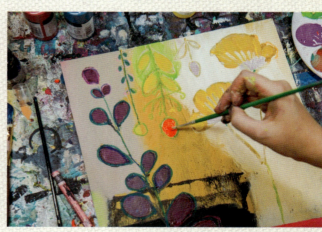

1. You may want to start with some neutral colors and then add some black for contrast. I used India ink, which works fine over acrylic paint as long as it's mostly dry. Spray some water onto your surface for some drippy effects. Spray it directly onto the ink. Tilt your surface upright and tap it to allow the water and pigmented drips to naturally fall. This creates a subtle drama to your work.

 Begin to add touches of fluorescent color (I am using hot pink here) for that extra "wow."

2. Draw in elements with pencil or water-soluble wax crayons. Watercolor pencils will also work. It's nice to draw in motifs when the paint is still damp to leave subtle pigment impressions. Paint in areas with bright acrylic paint. You can also color in areas with your wax crayons.

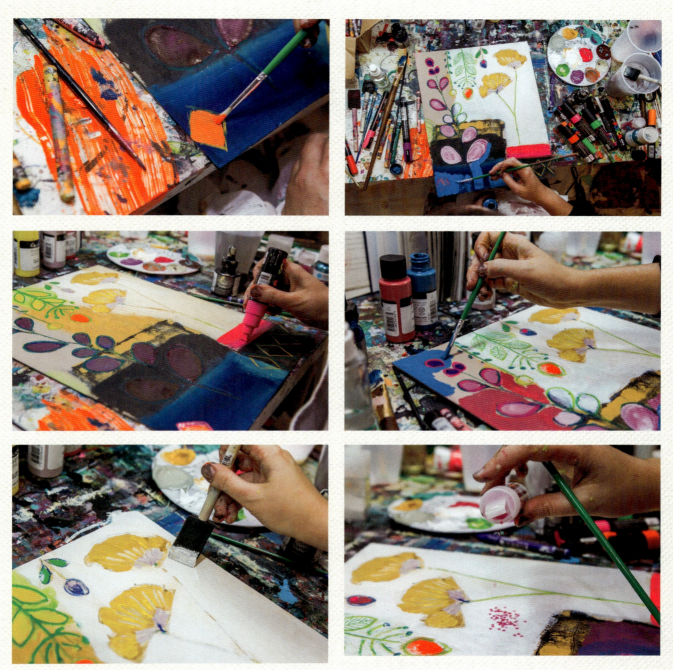

3. Outline some of your motifs with water-based paint pens. I like to work with paint pens in all thickness sizes (extra fine, fine, medium point, etc.). Paint around your motifs to give your work some nice defined edges. Flat, foam or angled brushes work best for this.

4. When the acrylic paint is still wet, add touches of glitter to it, which will naturally set into the paint. Add finishing details with paint pens (to define the edges) and if desired, seal the work with clear varnish when complete.

More Inspiration

A Gallery to Get You Painting!

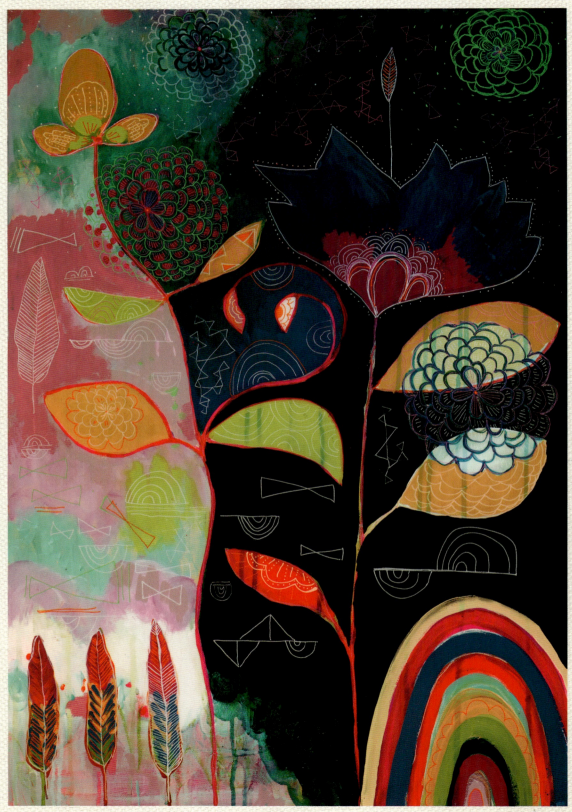

Sign up for our free newsletter at CreateMixedMedia.com.

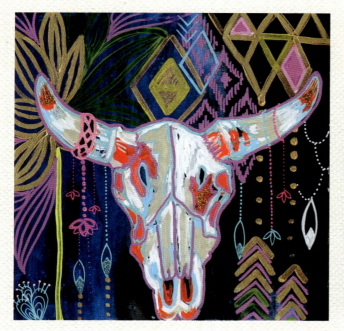

Rachael Rice

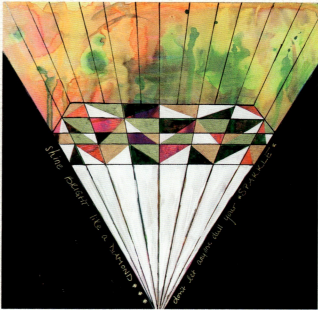

Lara Cornell

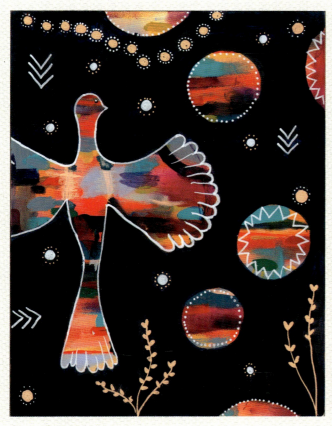

Ciarrai Samson

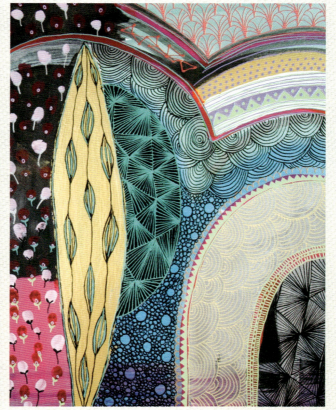

Lyn Metcalf

For additional downloads from the book, go to: CreateMixedMedia.com/IntuitivePaintingWorkshop.

55

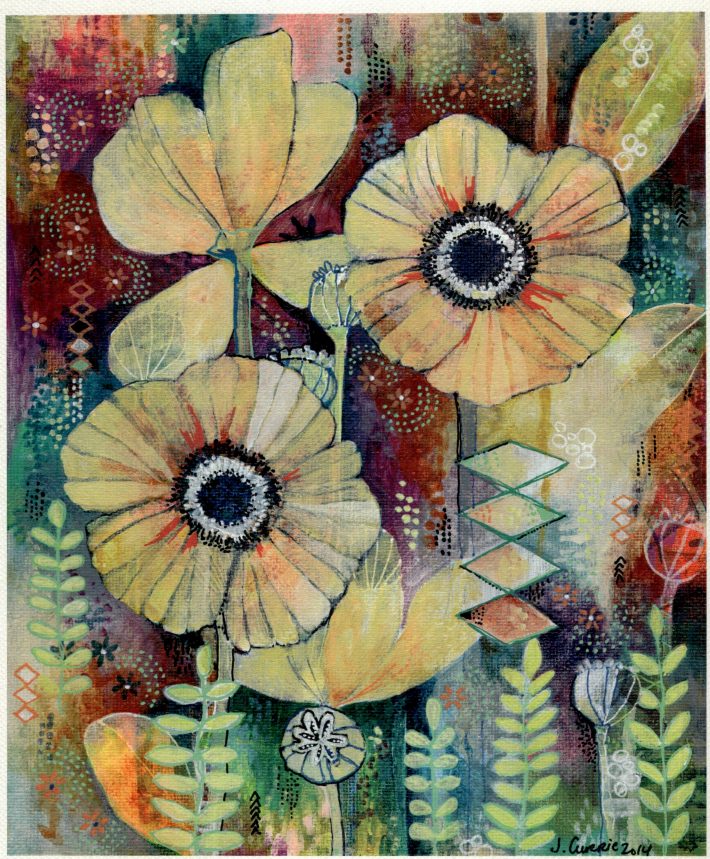

Jennifer Currie

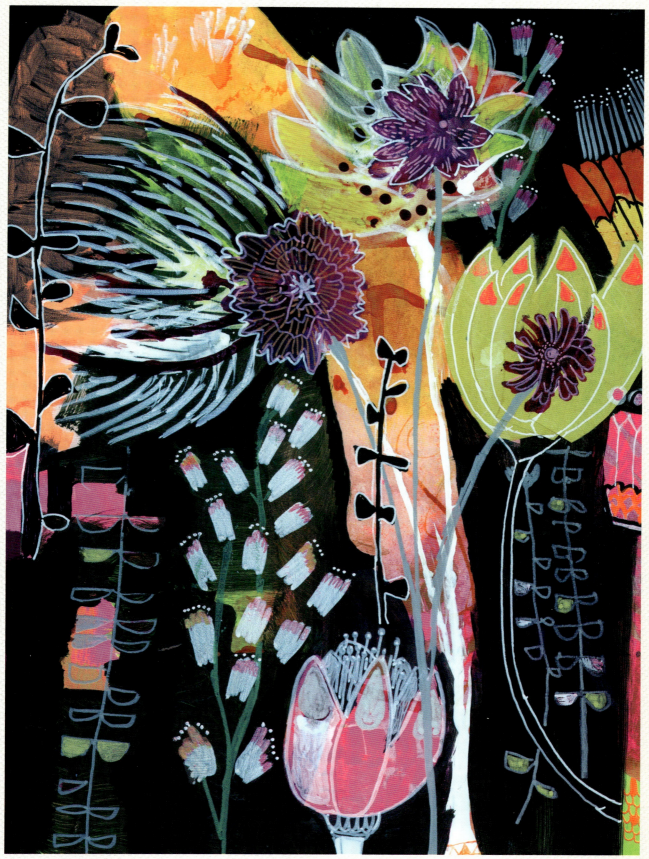

Julia Godden

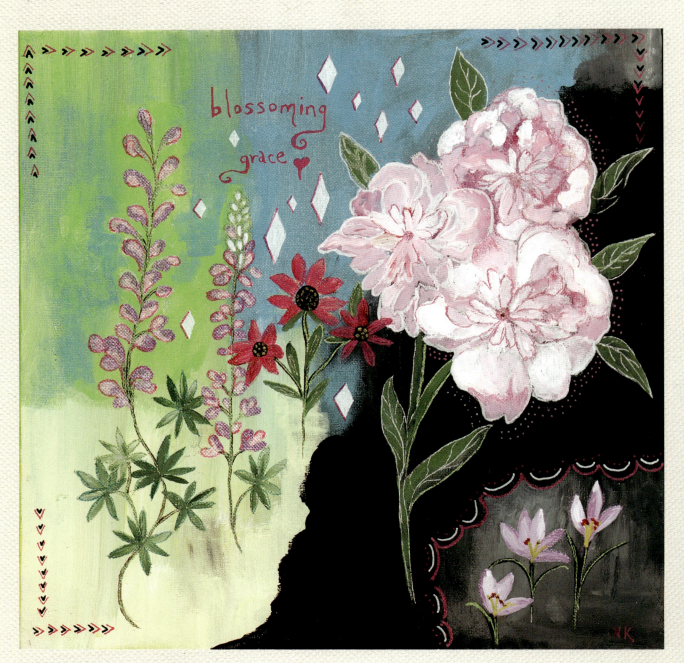

Navneet Khalsa

Sign up for our free newsletter at CreateMixedMedia.com.

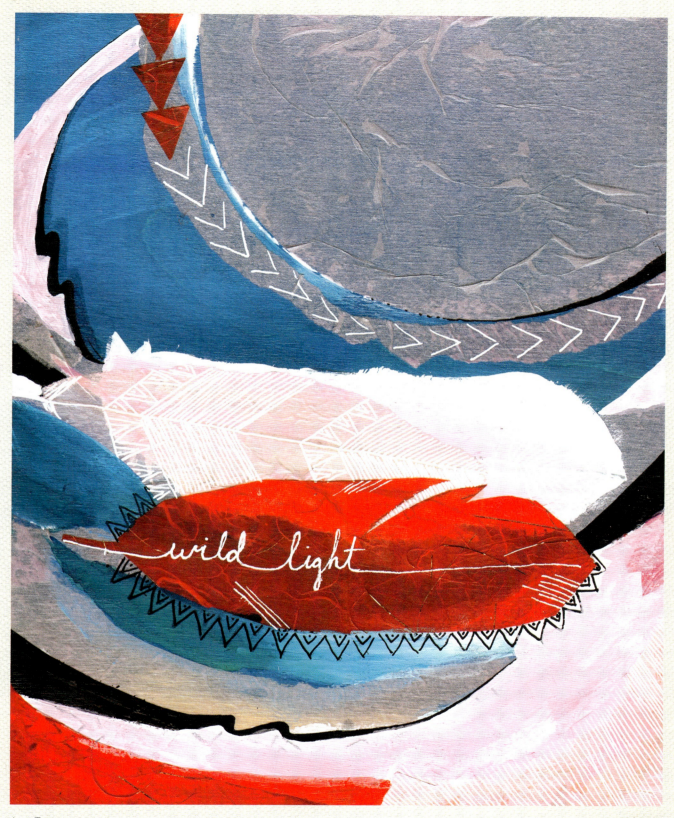

Lisa Tsering

For additional downloads from the book, go to: CreateMixedMedia.com/IntuitivePaintingWorkshop.

59

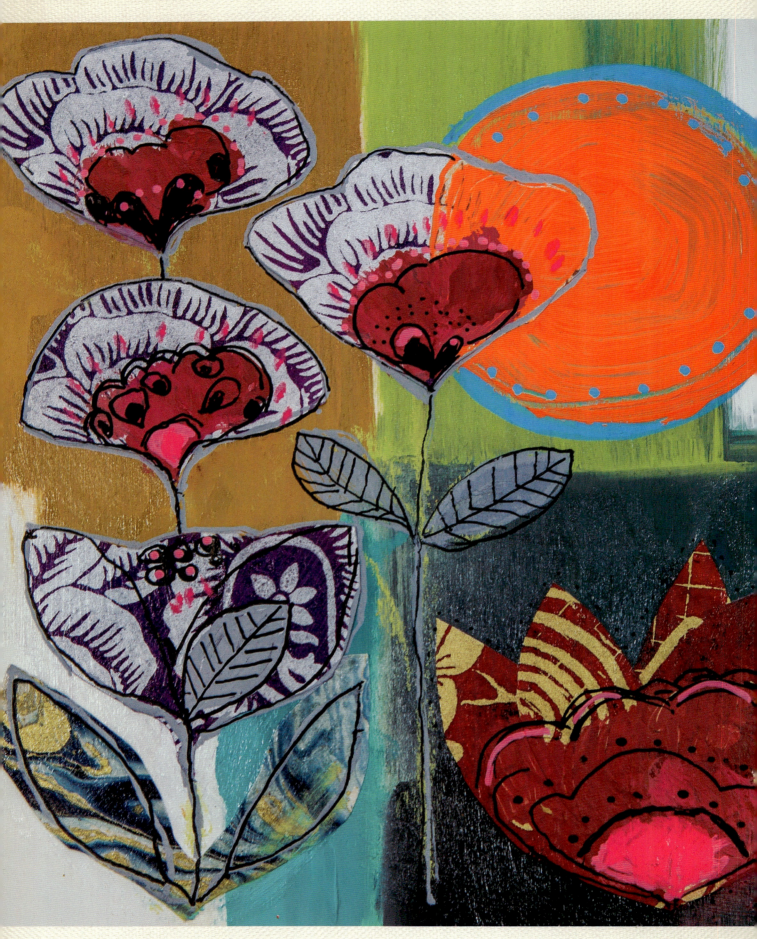

May

Get out into the garden and explore the infinite and fantastic world of botanical shapes and motifs. Create layers of paint and paper to create beautiful works of art that shine out just in time for spring. Your walls will thank you for this lesson.

Step-by-Step Demo: **Botanical Beauty**

What You Need

Acrylic paint
bright colors you enjoy, including fluorescents and neutrals

Clear spray varnish

Decorative papers
non-coated with a soft or handmade feel

Matte or gloss medium

Paintbrushes
for acrylic painting: foam and flat

Pencil

Scissors

Smock

Surface
canvas board, wood panel or Gessobord

Water cup

Water-based paint pens
and/or Neocolor II Artists' Crayons

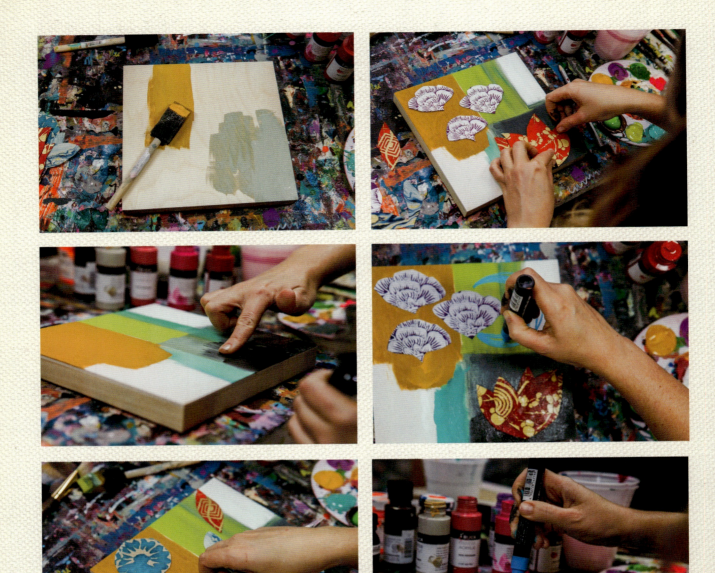

1. Paint the background of your surface. I am painting in pastel colors including white. Cut out a variety of floral shapes from decorative papers. You may wish to sketch out the shapes first with a pencil on the paper. Look to a reference book on flowers if you need help with getting ideas for designs.

2. Once the surface is dry, begin to arrange the botanical shapes onto the surface. Apply the paper with gloss or matte medium, using a flat brush. Lay a thin coat on the bottom and top of each piece of paper.

 Color in parts of your work with paint pens, adding more solid layers of color like I did by drawing in this blue circle and then filling it.

Sign up for our free newsletter at CreateMixedMedia.com.

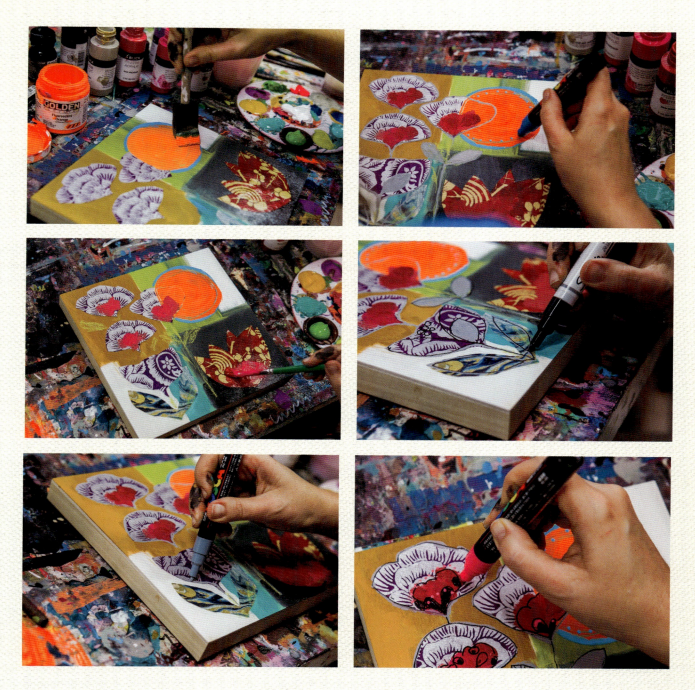

3. Add additional colors of paint to the surface to blend and highlight certain areas. Remember, you can paint on top of the paper, too to give the work more depth. Outline some of your shapes and motifs with paint pens.

4. You may want to choose a color that strongly vibrates against the other colors, as in a complementary color theme.
 Continue to add tiny details and refine or accentuate certain elements with paint pens. I love using black to really help certain elements stand out. Seal with spray varnish when finished.

For additional downloads from the book, go to: CreateMixedMedia.com/IntuitivePaintingWorkshop.

63

More Inspiration
A Gallery to Get You Painting!

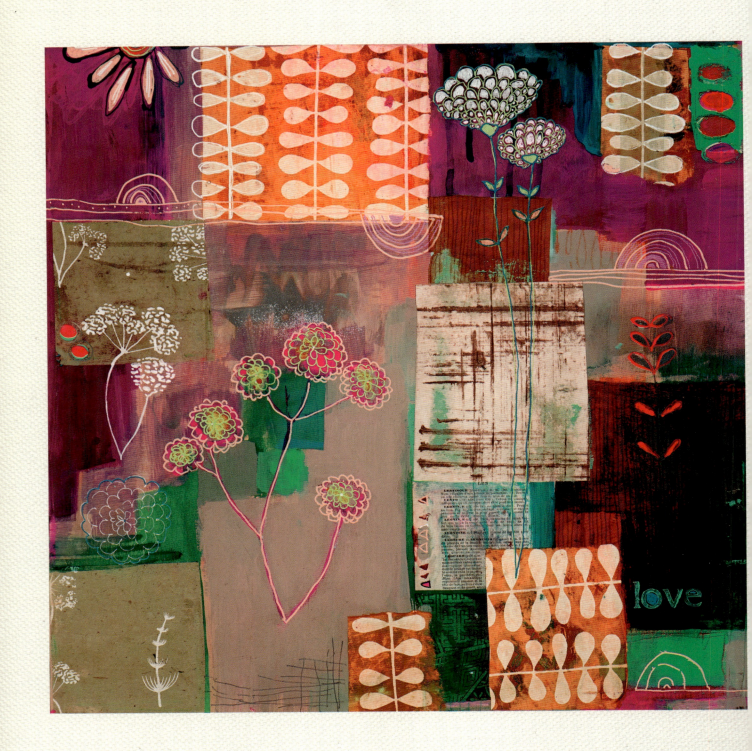

Sign up for our free newsletter at CreateMixedMedia.com.

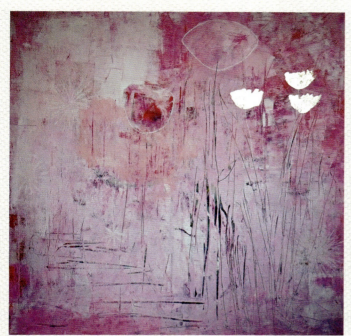

Cathrin Gressieker

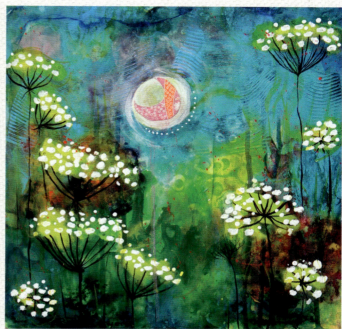

Robin Conyers

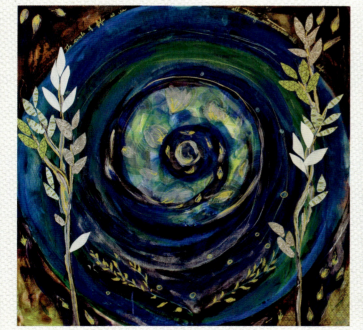

Michelle Blades

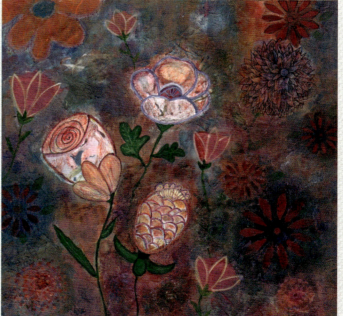

Alejandra Equiza

For additional downloads from the book, go to: CreateMixedMedia.com/IntuitivePaintingWorkshop.

65

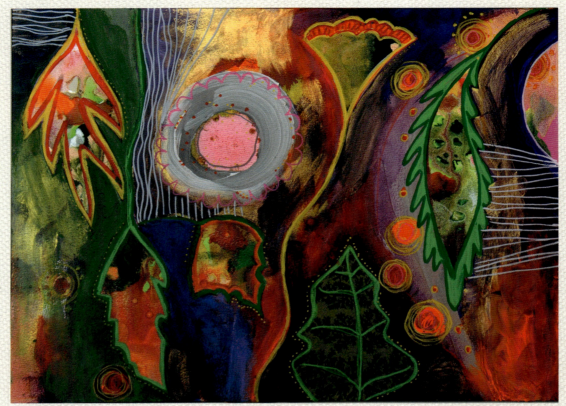

Kristi Shreenan

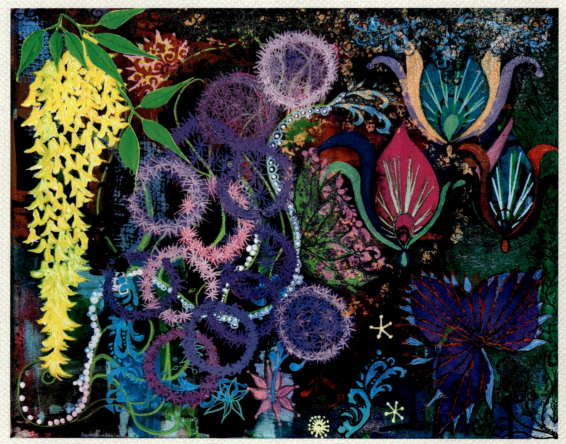

Grace Morgan

Sign up for our free newsletter at CreateMixedMedia.com.

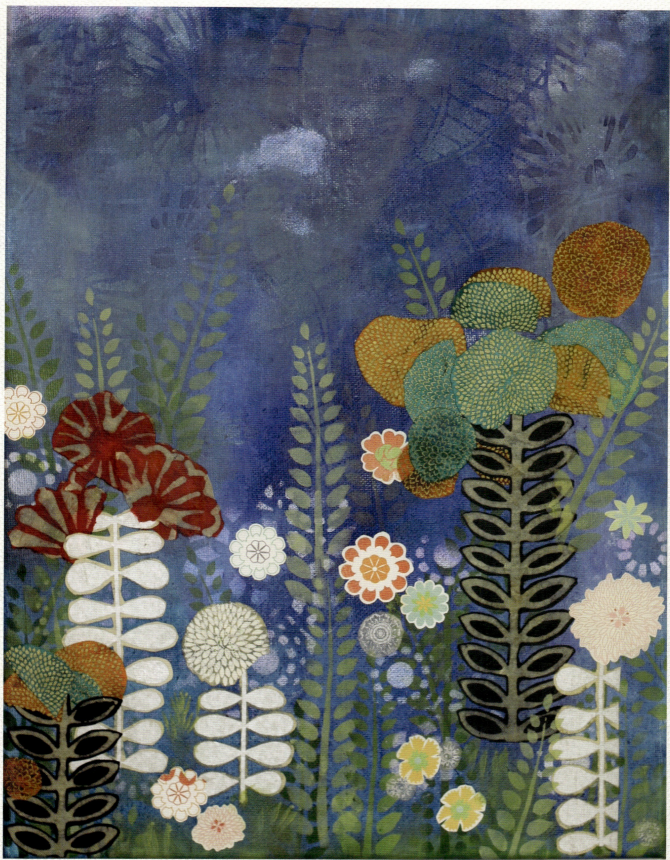

Jeanne Tierno

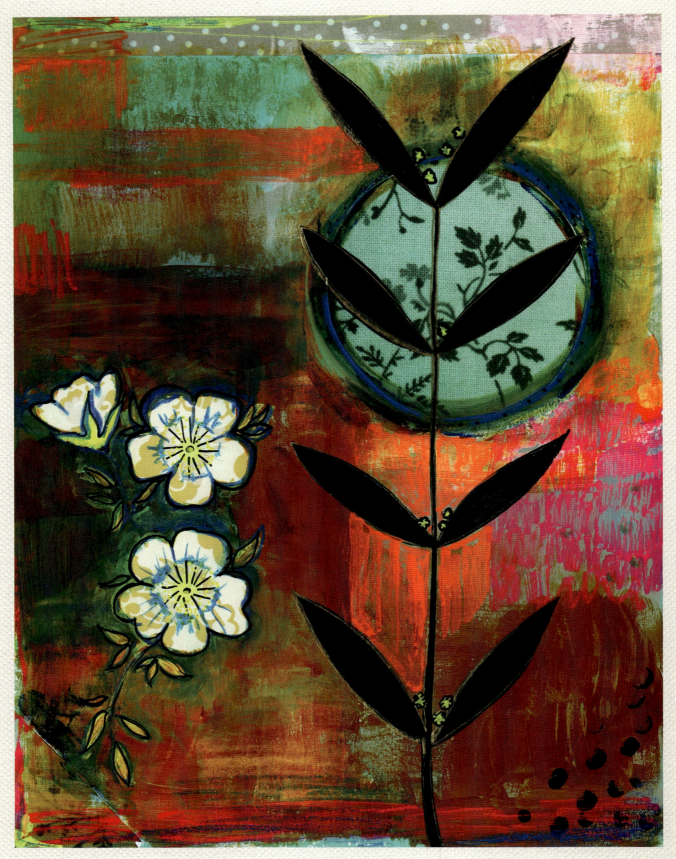

Rebecca Kim

Sign up for our free newsletter at CreateMixedMedia.com.

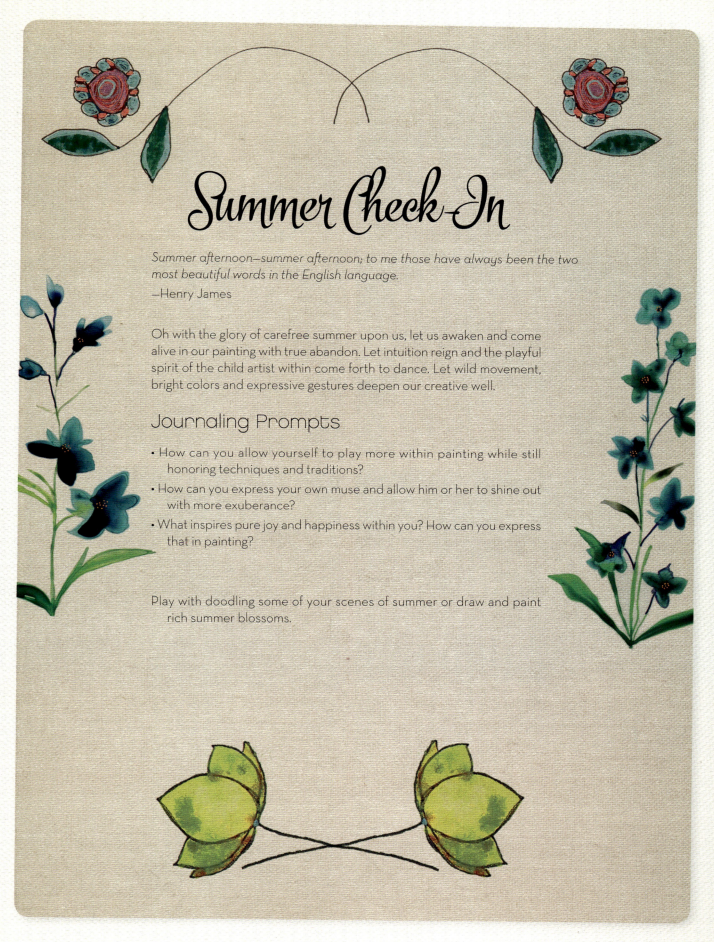

Summer Check-In

Summer afternoon—summer afternoon; to me those have always been the two most beautiful words in the English language.
—Henry James

Oh with the glory of carefree summer upon us, let us awaken and come alive in our painting with true abandon. Let intuition reign and the playful spirit of the child artist within come forth to dance. Let wild movement, bright colors and expressive gestures deepen our creative well.

Journaling Prompts

- How can you allow yourself to play more within painting while still honoring techniques and traditions?
- How can you express your own muse and allow him or her to shine out with more exuberance?
- What inspires pure joy and happiness within you? How can you express that in painting?

Play with doodling some of your scenes of summer or draw and paint rich summer blossoms.

For additional downloads from the book, go to: CreateMixedMedia.com/IntuitivePaintingWorkshop.

69

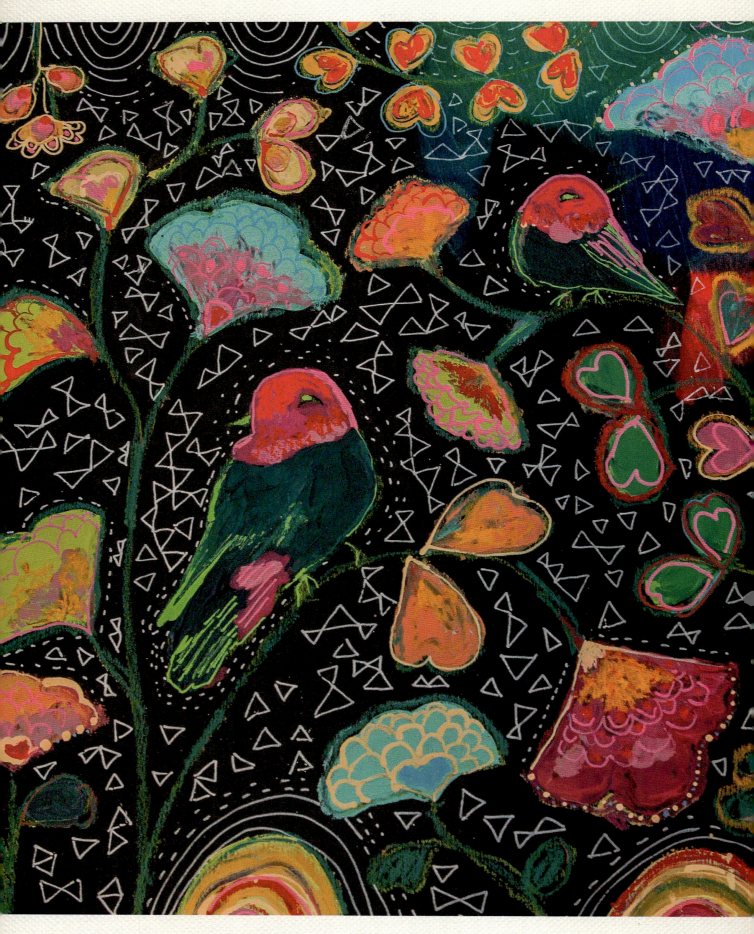

June

The clearest way into the Universe is through a forest wilderness.
—John Muir

The four-legged, winged ones or undersea creatures will help guide this next painting exercise. In this lesson, animal totems can serve as spirit guides for the soul. Research which animal(s) you most connect to; each has its own myth and symbolism, and each brings its own wisdom and gift. This lesson has always proven to be a favorite among my students, who seem to soar high when painting nature's living creatures.

Let your imagination run wild with this lesson and look at all the beautiful examples given to inspire you. If you are a beginner, it's important to know that lots and lots of practice makes everything better. Be patient and gentle with yourself.

Step-by-Step Demo: **Animal Totem**

What You Need

Acrylic paint
bright colors you enjoy, including fluorescents and neutrals

Clear spray varnish

Gesso

Inks
acrylic ink or India ink

Paintbrushes
for acrylic painting: round, flat, angled and foam

Pencil

Sketchbook

Smock

Surface
canvas board, wood panel or Gessobord, or Aquabord

Water cup

Water-based paint pens
and/or Neocolor II Artists' Crayons

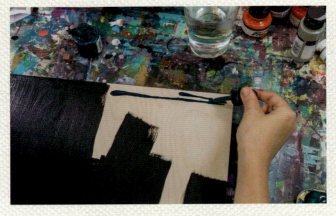 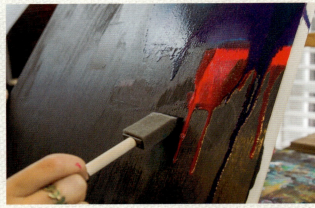

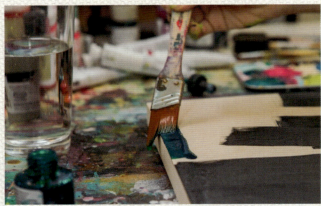 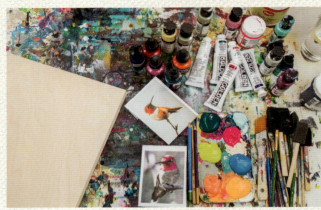

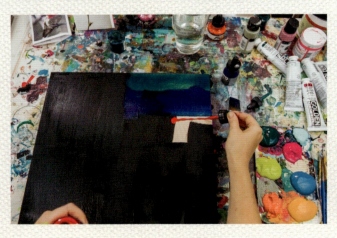 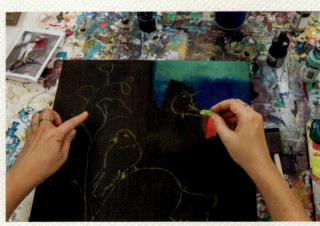

1. First research online the animal you would like to paint, printing out several views of this animal, along with any fitting landscape it belongs in. Use that as reference material to look at and draw from. (This helps so much!) Practice first in your sketchbook if you would like, and create magical scenery around it to bring out your spirit creature's magic!

Apply acrylic or India ink directly to a wood panel. Alternatively, you can also apply gesso and then work with acrylics or the inks. Whatever you choose, pick just a few colors to start with. Starting with a wash of black works well for me, then allowing a few colors to contrast. Simply apply ink with a foam brush or a dropper.

2. Play with the drips and let the ink run wild. After your background is dry, draw in your animal(s) and any scenery around it using a wax crayon or other dry media. You may want to sketch it in pencil first if that's easier.

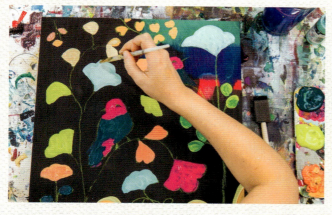

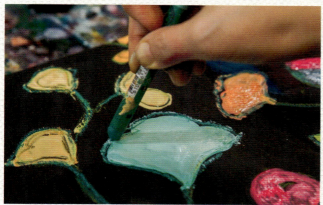
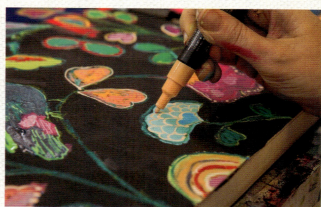

3. Go back in with your wax crayons and add details and texture to your imagery, coloring in areas you have sketched. When the acrylic paint is dry underneath, you can use paint pens to embellish and create further interest and detail in your work.

Continue to layer this piece; give it all the attention it deserves. Walk away from it a bit. (I always like to give my paintings breathing room; it helps so much to come back and see them with fresh eyes!)

4. I know a painting is complete when I feel that "inner click" or knowing that it's done. With a lot of practice, I have learned to recognize that feeling. If there is something tugging at me or is bothering me about the work, I know it's not quite done or some changes need to be made. Space always helps me to come back and rework or add more layers. Be patient with this process. Some paintings come out so easily and effortlessly, and some require more time and energy. Let the work speak to you and don't force the process. Spray your work with varnish when you are finished.

More Inspiration

A Gallery to Get You Painting!

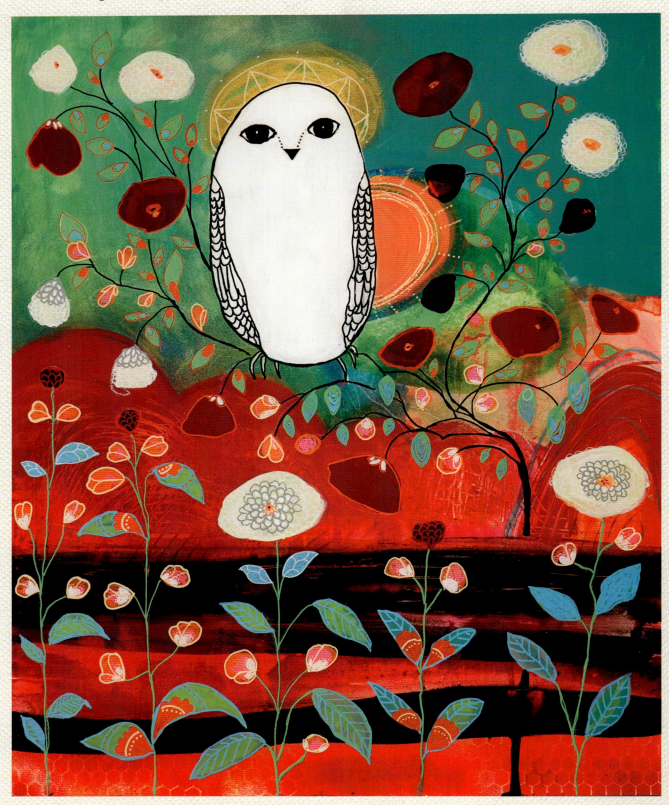

Sign up for our free newsletter at CreateMixedMedia.com.

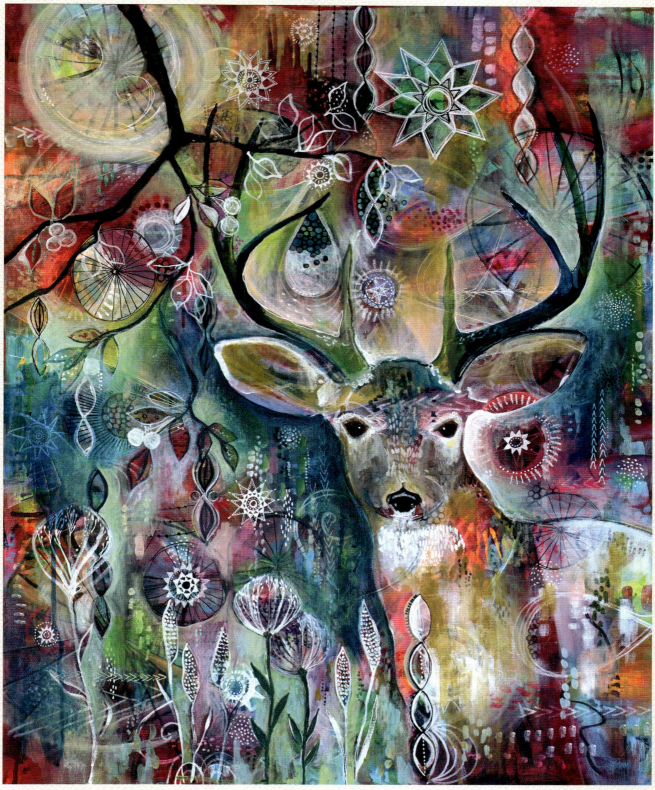

Jennifer Currie

For additional downloads from the book, go to: CreateMixedMedia.com/IntuitivePaintingWorkshop.

75

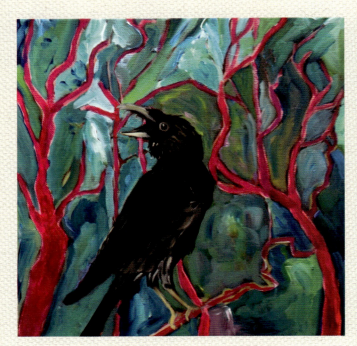

Tara Francesca

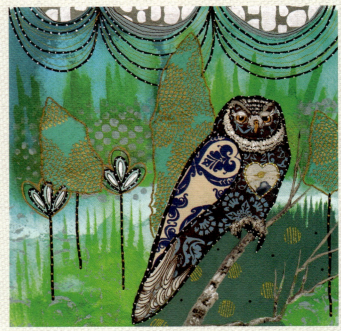

Robin Lee Devereaux

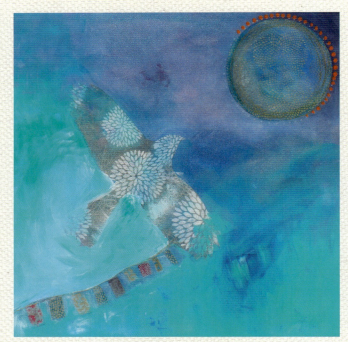

Paula Madonna

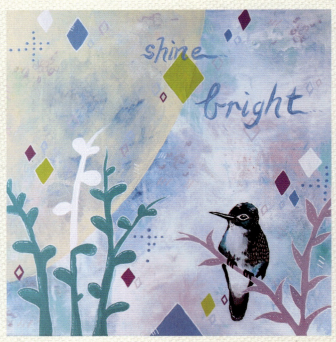

Kelly Zarb

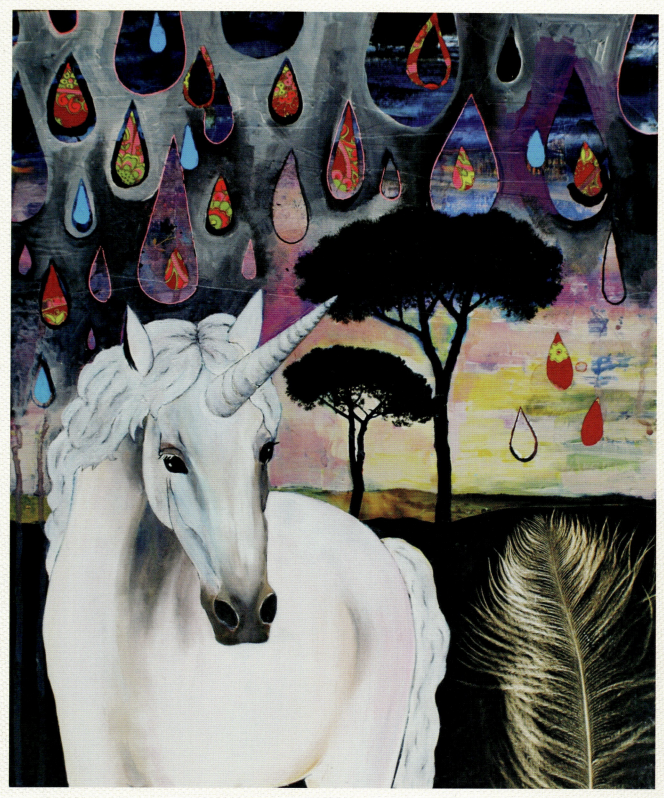

Ida Glad

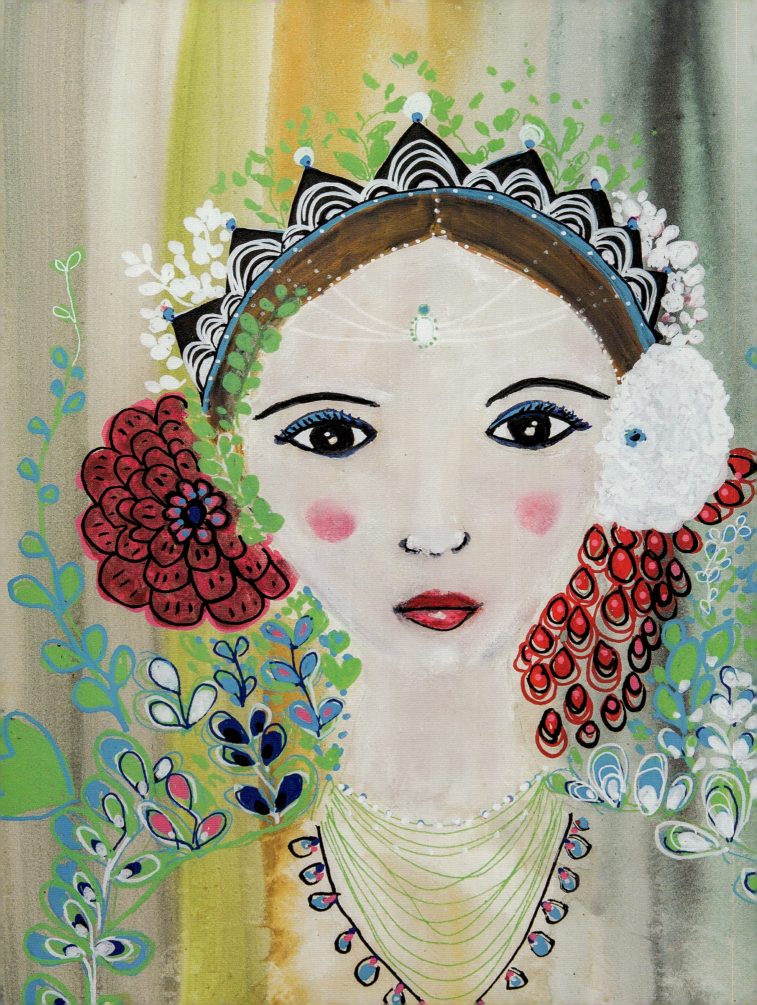

July

The face is a picture of the mind with the eyes as its interpreter.
—Marcus Tullius Cicero

Paint a muse portrait that is wildly adorned and an expression of your own self in this hot summer exercise. Portrait painting does not have to be intimidating but pure fun and delight. Adorn your muse with flowers, garlands, stems, crowns, birds, dripping blossoms, moons, jewels or whatever you fancy. The mission of this lesson is to bring your fantastical muse to life! Allow her or him to shine out and be mysterious, pure, sensuous, vibrant or however she or he speaks to you. We are exploring expressive portraiture, not the realistic sort.

If you're intimidated by faces, study images ahead of time or look for a tutorial before you begin. Simply do a Web search on "how to draw a face," and you will find good resources and even instructional videos online on how to do this.

Step-by-Step Demo: **Bewitching Portraits**

What You Need

Acrylic paint
> bright colors you enjoy, including fluorescents and neutrals

Clear spray varnish

Gel pens

Inks
> acrylic ink or India ink

Paintbrushes
> for acrylic painting: round, flat and angled

Paper towels

Pencil

Smock

Surface
> canvas board, wood panel or Gessobord, heavy watercolor paper or Aquabord

Water cup

Water-based paint pens
> and/or Neocolor II Artists' Crayons

White eraser

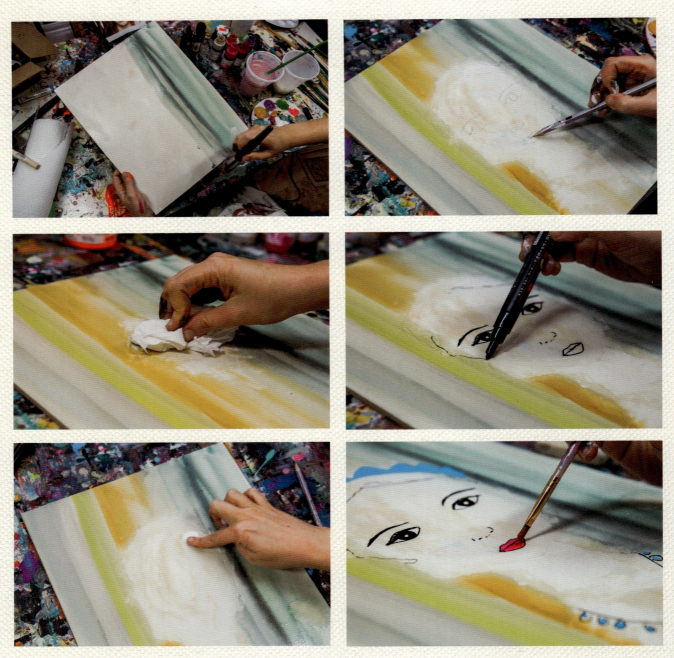

1. Start out with a light wash of inks, especially if working on Aquabord or watercolor paper. I like to work in just a few washes by applying a good amount of water to the Aquabord, then blotting up the ink with a paper towel in the areas where I will draw the face. This creates a nice wash for where the face will go. As an option, you can paint a thin wash with an out-of-the-ordinary color for a face (like lavender, green, etc.) for a unique and expressive portrait! Let your imagination be your guide.

2. After your background is dry, begin to pencil in the face. When you feel ready, take a pencil and a good white eraser and draw the face in faintly and loosely.

Take a dark paint pen (I used black in this example) and begin to outline the features of the face. Work slowly and carefully. Less is more when working on the face, and layering little by little really helps. We are not aiming to make this face perfect but artful and expressive. I feel any quirkiness or eccentric details help to make it that much more endearing.

Take a small round brush loaded with paint or ink and fill in the lips. I like to make the upper lip slightly darker than the bottom, as it's usually under a shadow.

Sign up for our free newsletter at CreateMixedMedia.com.

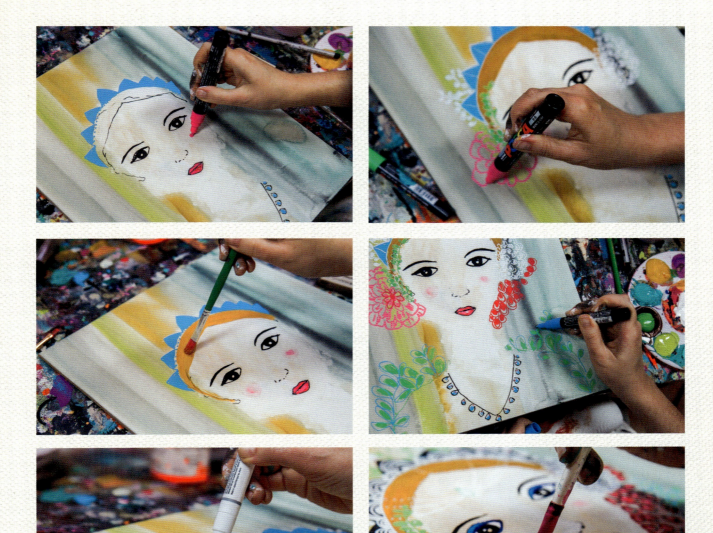

3. Add some color to the cheeks. You can also use paint pens to fill in these features (or both). Begin to paint in the hair, jewels, crown or whatever you have lightly sketched in to adorn your muse. Layer away. As always, wait for the paint to dry before adding more refined details with paint pens.

Remember, simple is sometimes best when doing expressive portraiture. Overworking a face has always gotten me into trouble, so I have learned that working gingerly is often the best way.

4. Allow any blooms, blossoms or other expressive motifs to expand and move in all directions around your muse. Sketch them first with pencil if you'd like, then fill in with paint and/or paint pens. Use lots of colors to give her or him an alive feel. Let your muse be adorned with things that excite and inspire you. Work in an up-and-down, circular and diagonal fashion.

You may also want to go back in with your water-soluble wax crayons and add highlights (with whites, creams, beiges, warm browns) and maybe touches of shadow. I like to add shimmery gel pens to my muse paintings; they add that extra touch of shine and detail. Lightly spray your finished work with a clear art varnish.

For additional downloads from the book, go to: CreateMixedMedia.com/IntuitivePaintingWorkshop.

81

More Inspiration

A Gallery to Get You Painting!

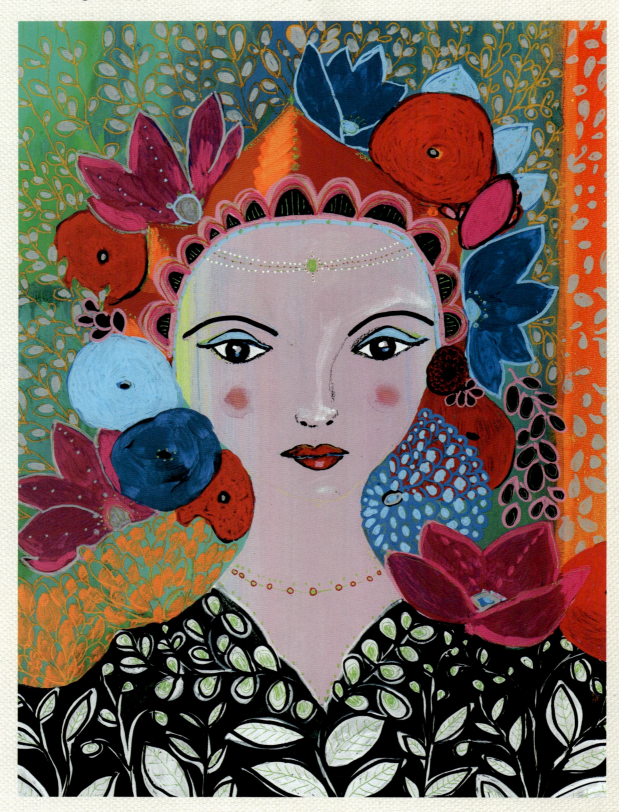

Sign up for our free newsletter at CreateMixedMedia.com.

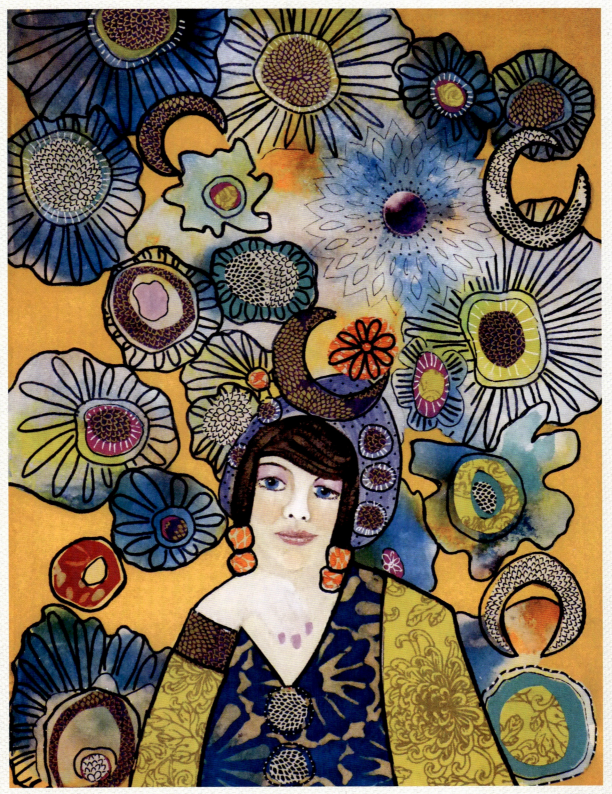

Robin Lee Devereaux

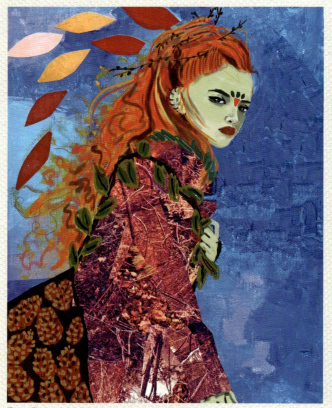

Tara Francesca

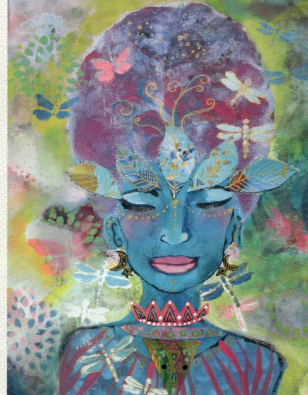

Susan Ciappara

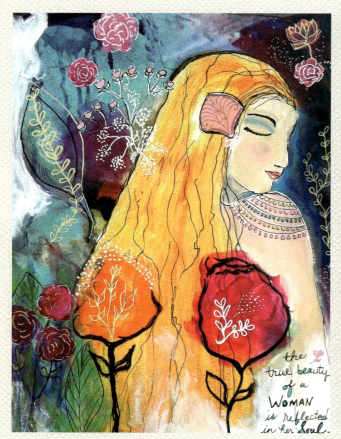

Renee Scheer

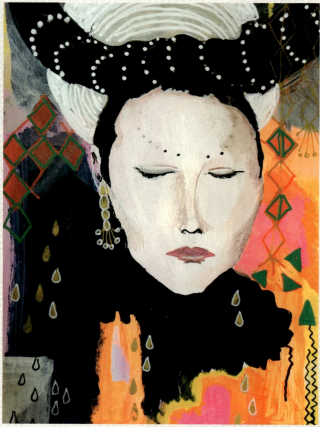

Julia Godden

Sign up for our free newsletter at CreateMixedMedia.com.

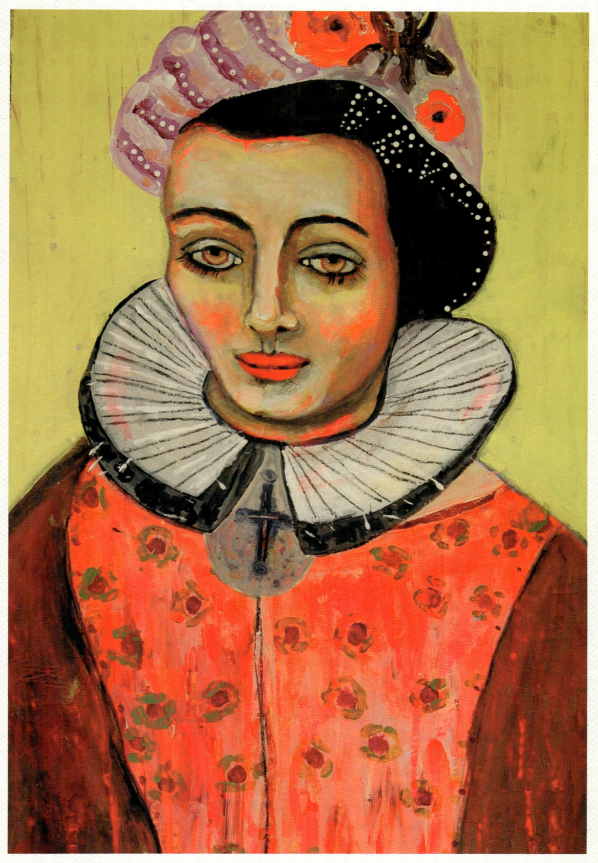

Dana Bloede

For additional downloads from the book, go to: CreateMixedMedia.com/IntuitivePaintingWorkshop.

85

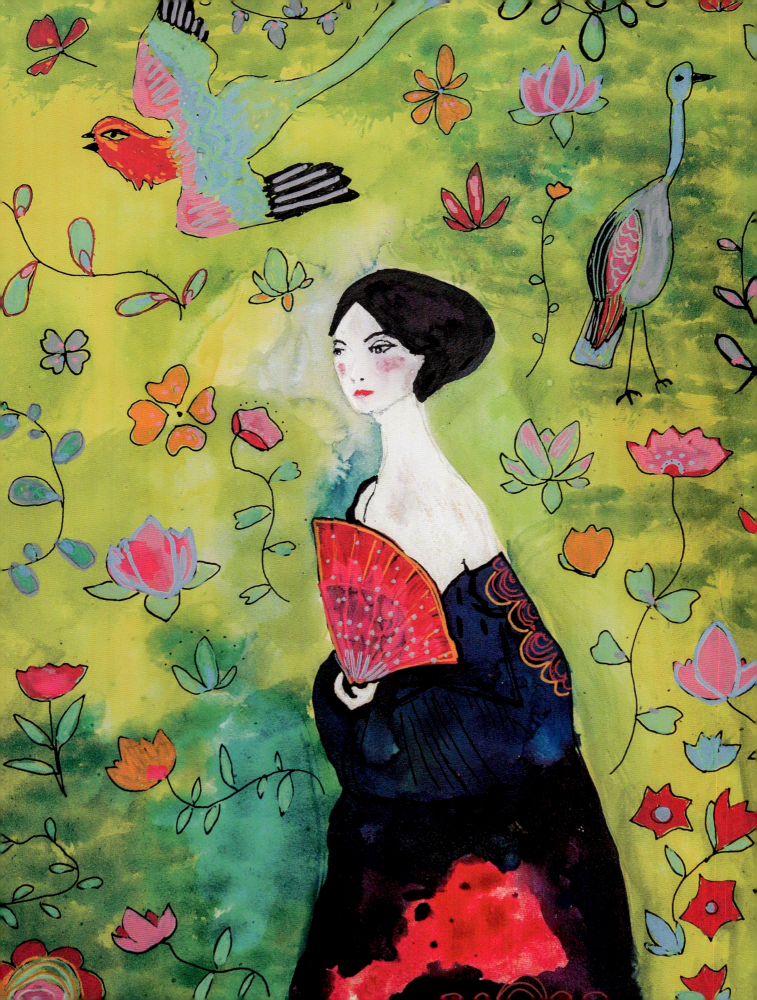

August

Every now and then one paints a picture that seems to have opened a door and serves as a stepping stone to other things.
—Pablo Picasso

Create a work inspired by a subject or subjects in a master painting and give it a unique twist! This is a challenging but incredibly fulfilling exercise that is quite helpful in evolving artistic skill and understanding. By taking a masterwork and making it our own, we honor art history and what it has taught us. Then, by adding our own aesthetic flair and style, we bring it up to date with modern twists and whimsical features. This is a wonderful study that can enhance your portfolio and learning in numerous ways.

Peruse the Internet or art history books for some of your favorite masterworks that have a person (subject) in them. Pick out several that you would like to try painting while still making them your own. I would suggest choosing one that challenges you just enough—not too much or too little. Pick one that moves you creatively and that you would enjoy working on. If you are searching online, print out copies from the Web.

Step-by-Step Demo: **Like a Masterwork**

What You Need

Acrylic paint
bright colors you enjoy, including fluorescents and neutrals

Clear spray varnish

Eraser

Inks
acrylic ink or India ink

Paintbrushes
for acrylic painting: round, flat and angled

Paper towels

Pencil

Sketchbook

Smock

Surface
wood panel or Gessobord, heavy watercolor paper or Aquabord

Water cup

Water-based paint pens
and/or Neocolor II Artists' Crayons

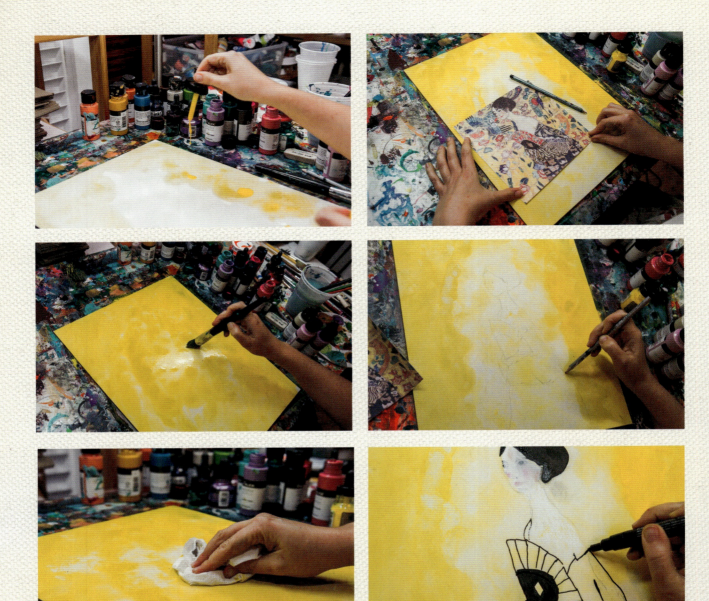

1. Practice sketching your subject in your sketchbook with a pencil and eraser. Imagine how you would change the surroundings or things about your subject and loosely sketch out those ideas as well.

 Brush some water over your surface and then drop some India or acrylic ink onto the wet surface. Use a brush to move the ink around and create a wash. Blot up the ink with a paper towel in the area where you want to add your subject.

2. Using your masterwork as a reference, begin to sketch your composition in pencil. When you are happy with your subject, start filling in areas of the skin and hair with your water-soluble wax crayons. You can also use ink or acrylic paint, but I love the creamy texture the crayons leave. Since they are water-soluble, you can blend colors nicely together with a small brush right on the surface. Use a range of warm fleshy tones for the skin. I like to add layers until it feels right and rosy pinks for the cheeks and lips.

 Begin to outline your subject with an extra-fine paint pen. Work delicately and slowly. You do not need to outline the entire subject right now; you can go back and fill in later.

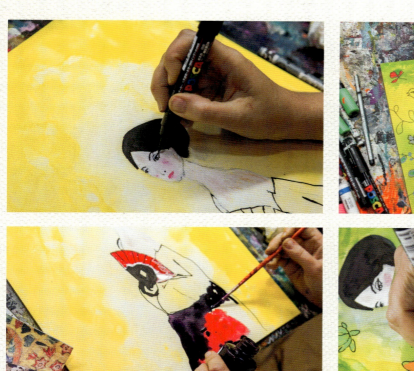
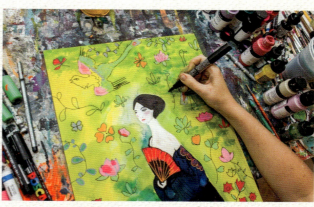
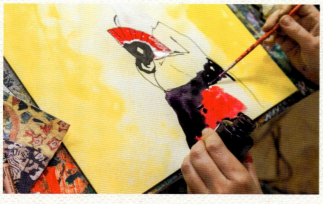
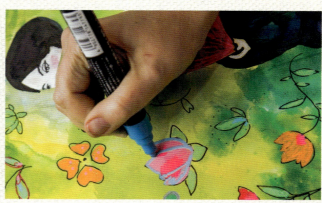

3. Take your extra-fine paint pen and fill in the features of the face. Work gingerly; less is more and you can always add more later. I like using blacks or browns to outline the features. I like using pinks and reds for the lips.

 With your inks or acrylics, fill in parts of your subject's clothing. Try using fluid washes and rich saturated colors that blend together to create bold material.

 Drop more ink around your subject to add new layers to the background. Try not to get too stuck in any area of the painting; continue to dance around. Keep your hand (and attention) on all areas of the painting as you apply more details or layers to the background. Layers make a painting feel well loved and give it depth.

4. When the layers of paint are mostly dry, sketch in whimsical details of your imagination or those inspired by your masterwork, but give them a unique and modern twist. Fill them in with ink and paint pens. Work with bright and bold colors, and remember, we are modernizing this work; that's why it's so much fun! Spray your work with varnish when you are finished.

For additional downloads from the book, go to: CreateMixedMedia.com/IntuitivePaintingWorkshop.

89

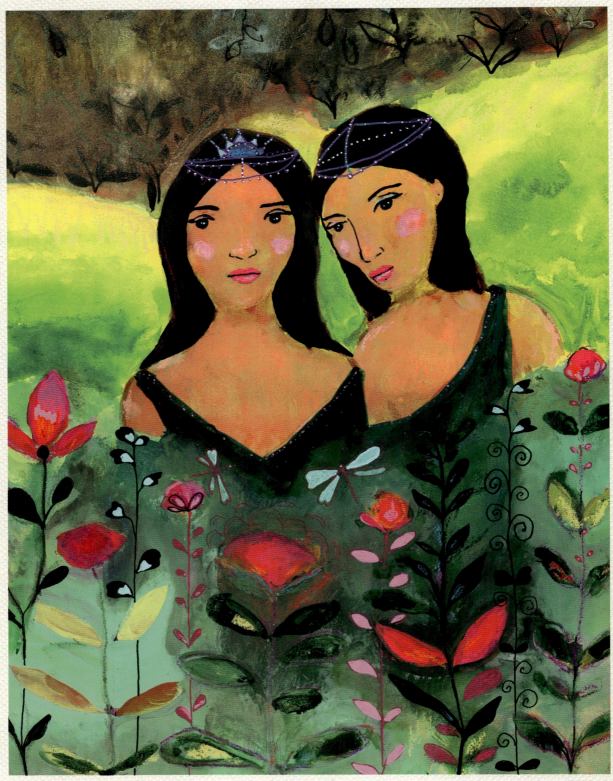

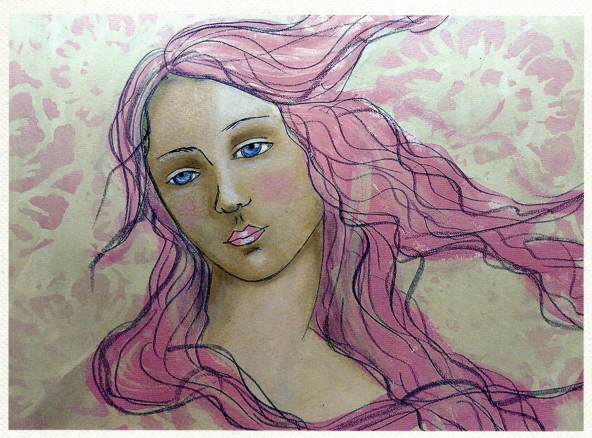

Colette Trad

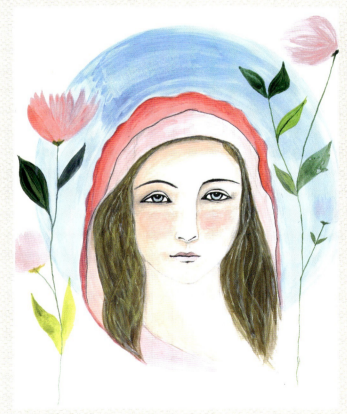

Cheryl Greene

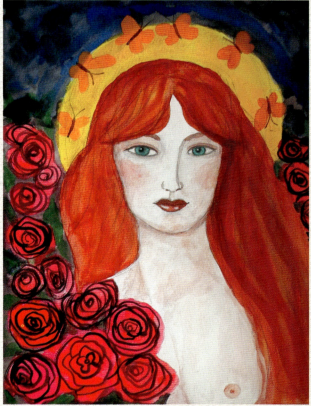

Cathrin Gressieker

For additional downloads from the book, go to: CreateMixedMedia.com/IntuitivePaintingWorkshop.

91

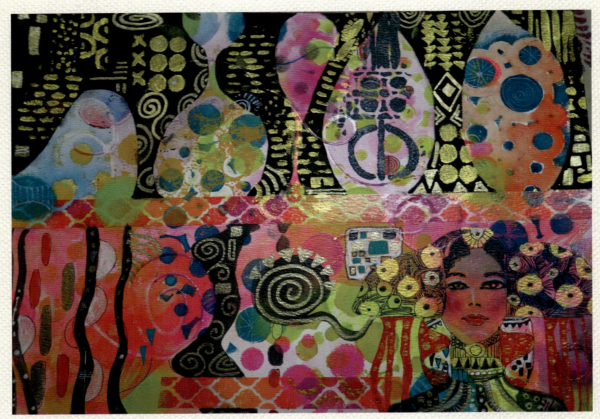

Susan Ciappara

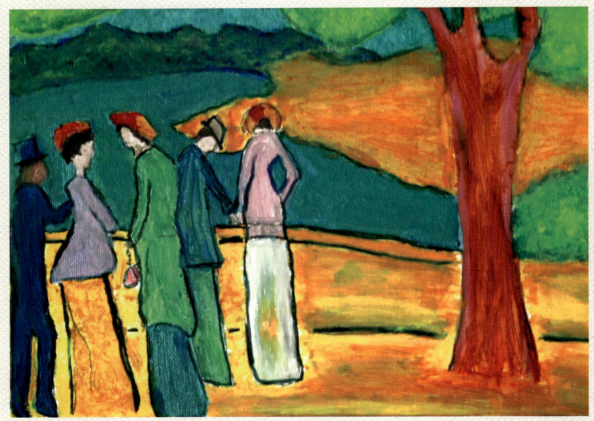

Janine Canady

Sign up for our free newsletter at CreateMixedMedia.com.

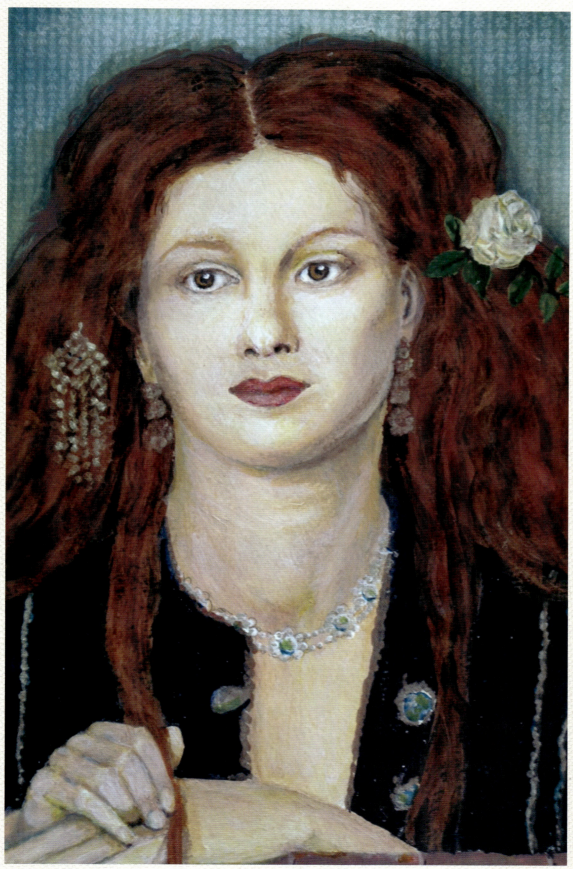

Jane Hennessy

For additional downloads from the book, go to: CreateMixedMedia.com/IntuitivePaintingWorkshop.

93

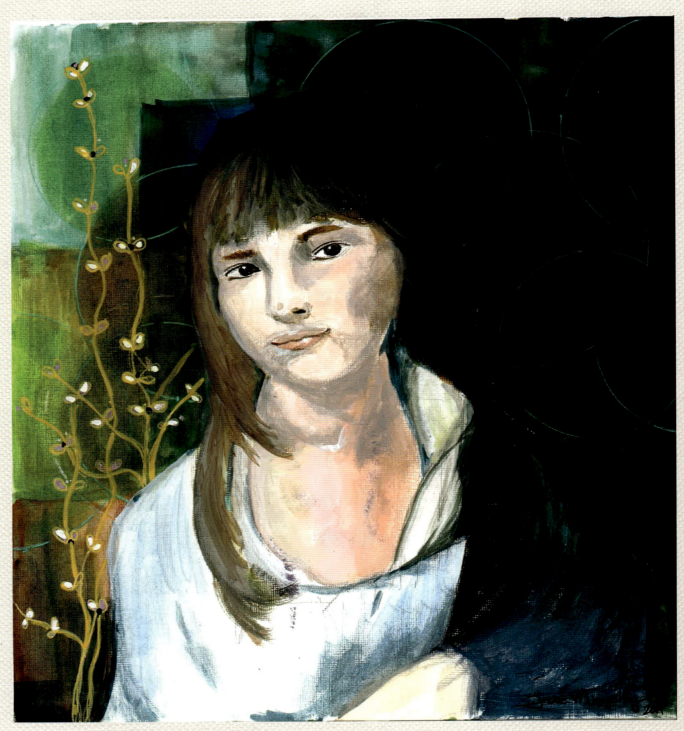

Lisa Murphy

Sign up for our free newsletter at CreateMixedMedia.com.

Autumn Check-In

Autumn carries more gold in its pocket than all the other seasons.
—Jim Bishop

Fall, to me, is about transformation. It's about letting go, just as the trees let go of their leaves and prepare for winter. It's also a delightful observance of earthy jewel tones—golds, reds, oranges and more. Let earthy colors make more of their way into your work, as they allow the bright colors to shine forth. Allow this season move you to create and to express the glory of beauty before death, just as all the leaves tenderly show us each year. Let the coolness in the winds speak to your artist soul.

Journaling Prompts

- In what ways can you take bold steps in letting go and letting your art shine forth more in your life?
- Besides leaves and trees, how can you express fall in your painting?
- How can you allow your paintings to come on fire from within? Spend even more time layering and giving each work more attention.

Practice drawing and painting leaves, trees and the colors of fall.

For additional downloads from the book, go to: CreateMixedMedia.com/IntuitivePaintingWorkshop.

95

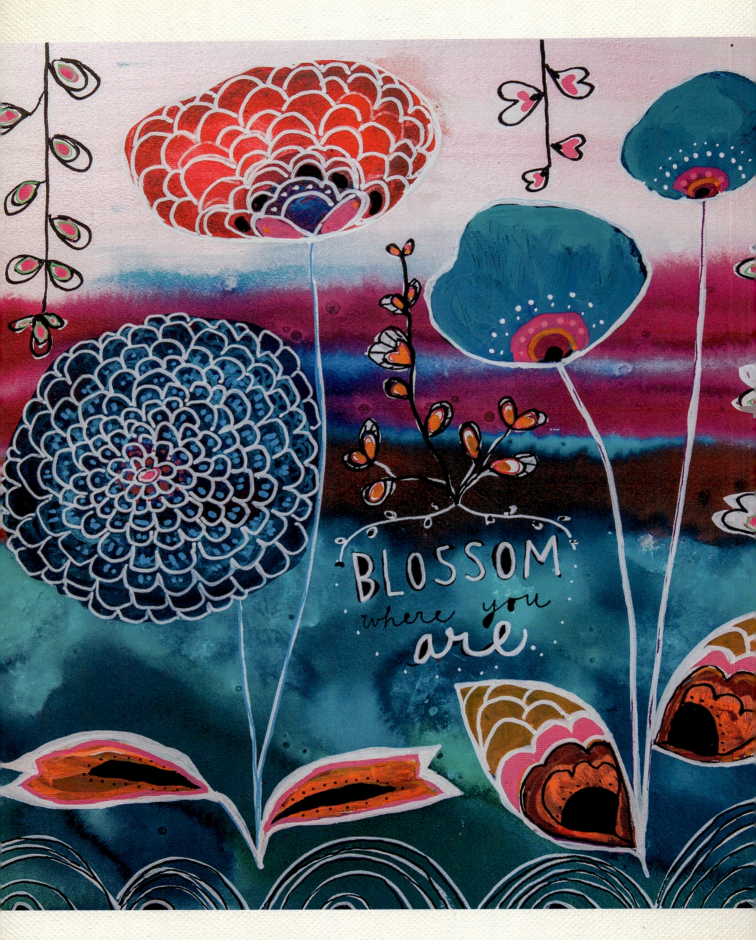

September

In this simple but freeing lesson, explore the magic of water as a powerful medium for painting. Dive deep into rich saturation and hues with the inks, and focus on movement and fluidity as principles of work, along with color relationships or how colors interact and change one another. This is a wonderful lesson to allow yourself to work totally by intuition and through the method of freedom—allowing instinct and wild abandon to take over. Don't overthink anything in this lesson—simply play and discover.

My absolute favorite surface to paint on in this lesson is an Aquabord. It works so beautifully with the water and inks and creates a real fluidity. You can also use thick watercolor paper or a Gessobord.

Step-by-Step Demo: Flying Fluid & Free

What You Need

Acrylic paint
colors you enjoy

Clear spray varnish

Gel pens

Inks
acrylic ink or India ink

Paintbrushes
for acrylic painting: soft round/mop, flat and angled

Paper towels

Sketchbook

Smock

Surface
Aquabord, heavy watercolor paper or Gessobord

Water cup

Water-based paint pens
and/or Neocolor II Artists' Crayons

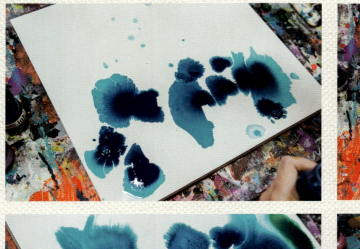

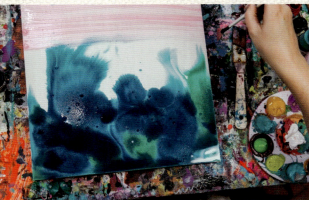

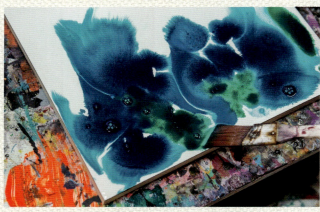

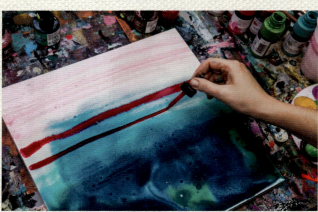

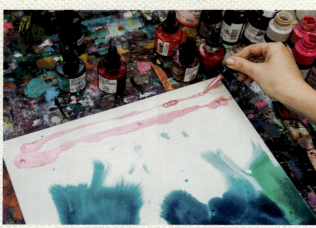

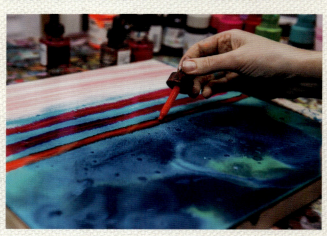

1. Start out by applying a good amount of water to your Aquabord. If you are using watercolor paper, make sure the edges are taped down with low-tack tape.

 Begin to add India and/or acrylic ink. Start with one or two colors and swirl them around, moving your brush in all directions and dancing with it over the substrate. Now apply a contrasting color over your first layer of ink. I love working with ink straight from the bottle.

2. Over the cool teal hues I am applying a rich blend of pink, orange and magenta. Let natural feathering or bleeding occur with the inks to give your painting a fluid or uninhibited feel.

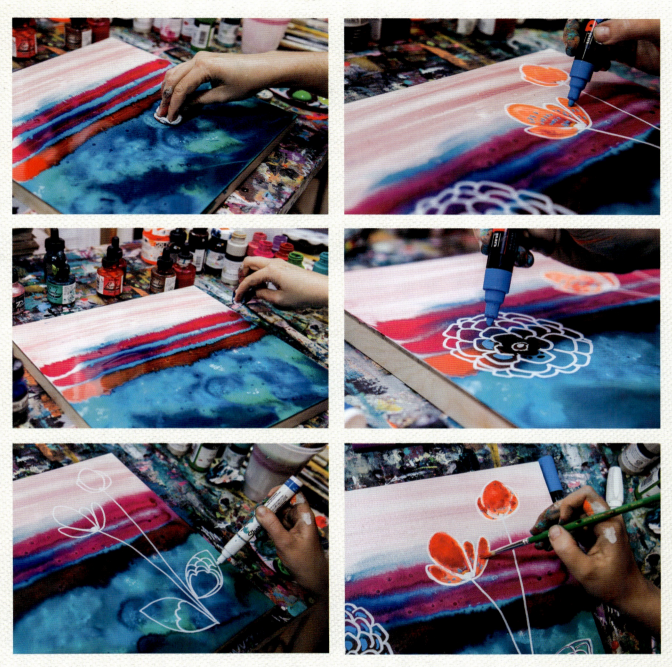

3. Use a paper towel to pick up any air bubbles. Once the ink background layers are mostly dry, begin to sketch out some motifs for your painting. If you wish to paint botanicals, you could work from your imagination or from a reference book. Find a great resource on flowers, herbs and other plants to look at for ideas. You may want to practice drawing them in your sketchbook first. Try different composition ideas and then draw directly onto your substrate. Outline your shapes with your paint pens.

4. Fill in your motifs with ink and paint pens once the ink is mostly dry. Continue to refine and add detail, which provides balance and contrast to the sweeping movements of rich color in the background. You can work directly from the ink bottles, too (as long as your brush is clean when you dip it back in).

For additional downloads from the book, go to: CreateMixedMedia.com/IntuitivePaintingWorkshop.

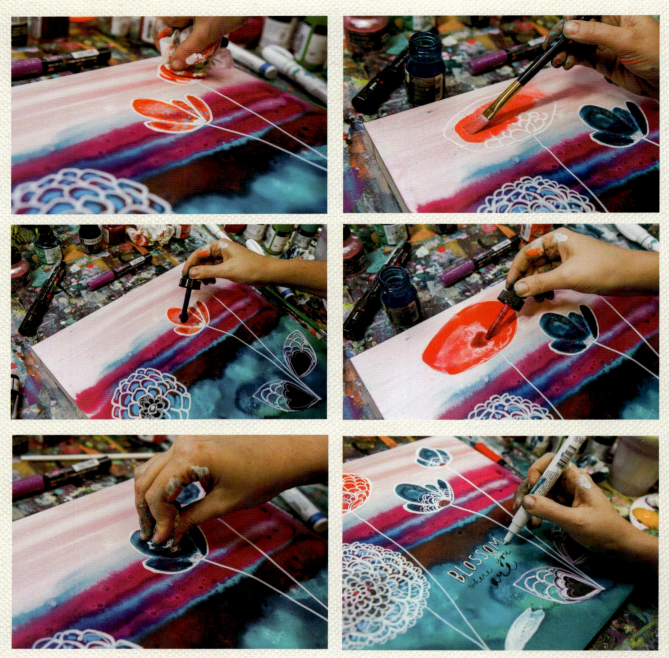

5. A paper towel works well to blot up some areas of heavy ink, creating highlights. It's fun to do this with one color atop another. Go back and forth between dropping ink and blotting it up.

6. Continue playing with washes in your outlined forms.

Consider adding script or text to your painting. What would you like it to say? Do you wish to look up a quote that relates to your painting? Do you want this to be an inspiration piece or a personal one just for you? These are the decisions we get to make as artists. Practice your script in your sketchbook first—and remember the script you write on the painting can first be done in pencil (which is less pressure), but it's also an element of design in the work. I like to write with both cursive and capital letters. Try first writing with fine- and medium-point paint pens, and once that layer is dry, outline it with white. This really helps the script to stand out and also be artful.

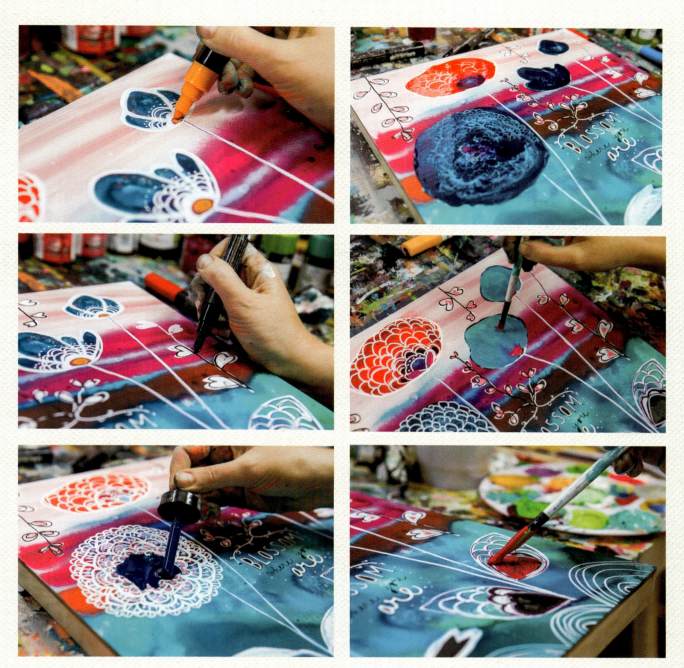

7. Add complementary colors to parts of your motifs using paint pens. Acrylic paint in some areas over the ink will add an interesting matte finish. Don't overdo your acrylic painting but keep it to a minimum to keep the fluid feel of this work.

Continue to add more color, detail and refinement to make all elements of the work (shape, line, form, color) stand out and be in harmony with one another.

8. Gel pens work well to add tiny shimmery details against the broader strokes. Unify your work by repeating certain elements and ways of creating or executing it. Repetition gives rhythm to a piece, which helps to create harmony.

Lightly seal the work with a spray varnish when you are finished, to protect it which also helps the more delicate areas to stay in place. If you worked on watercolor paper, you won't have to do this.

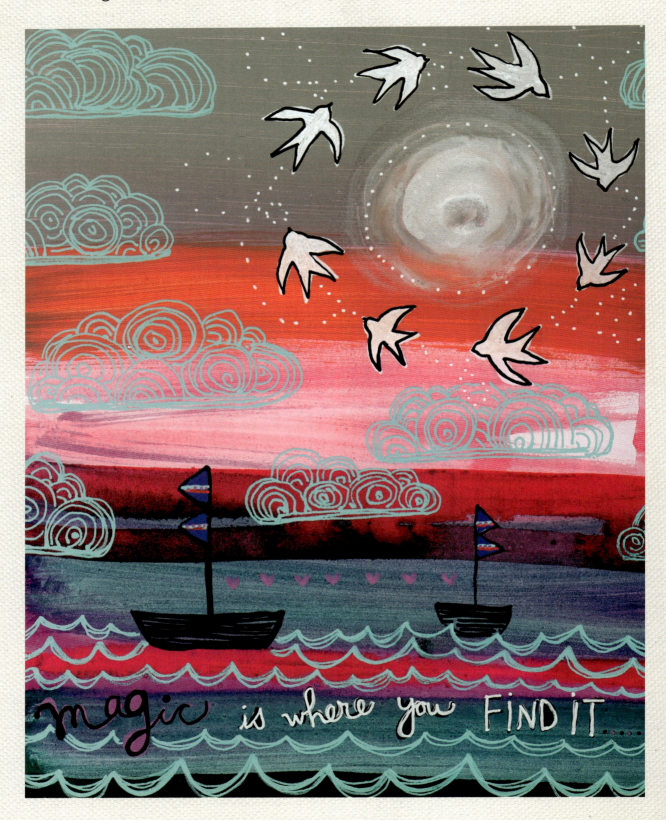

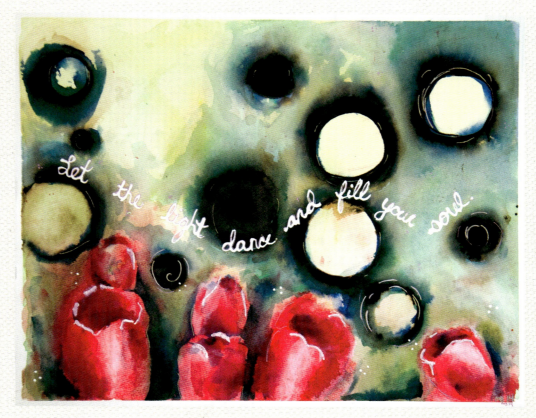

Michelle Blades

Lisa Tsering

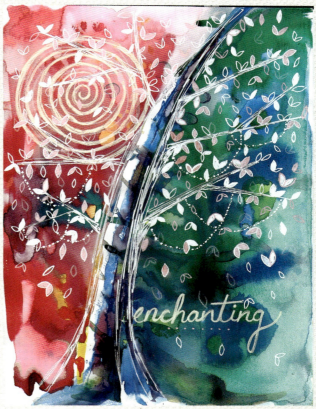

Lara Cornell

For additional downloads from the book, go to: CreateMixedMedia.com/IntuitivePaintingWorkshop.

103

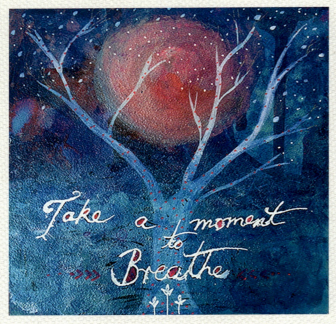

Colette Trad

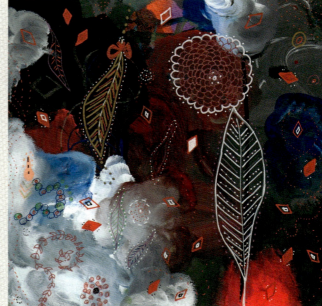

Susanne Leusman

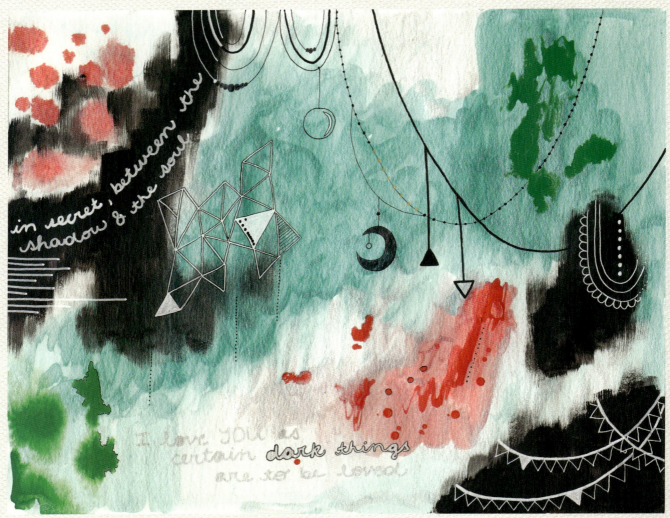

Ana Campos

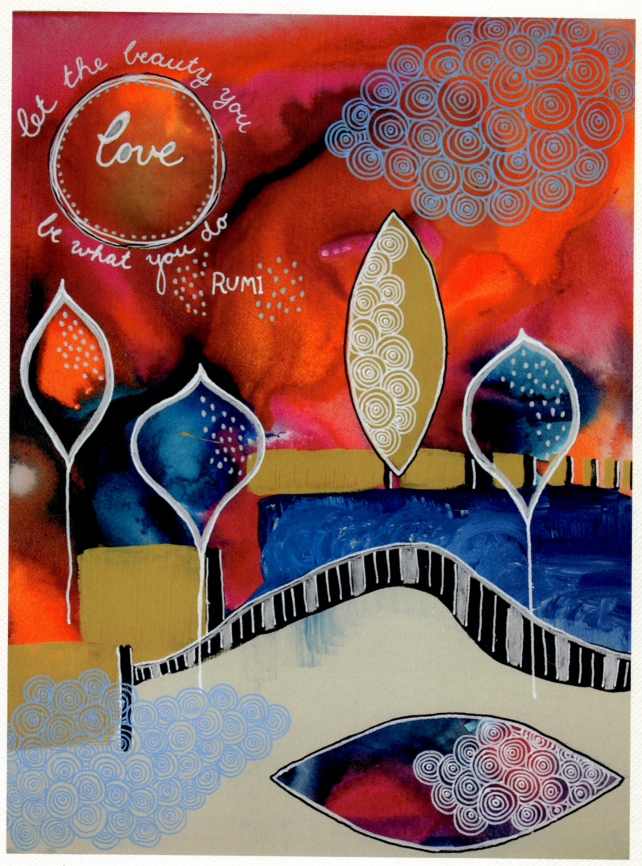

Lyn Metcalf

For additional downloads from the book, go to: CreateMixedMedia.com/IntuitivePaintingWorkshop.

105

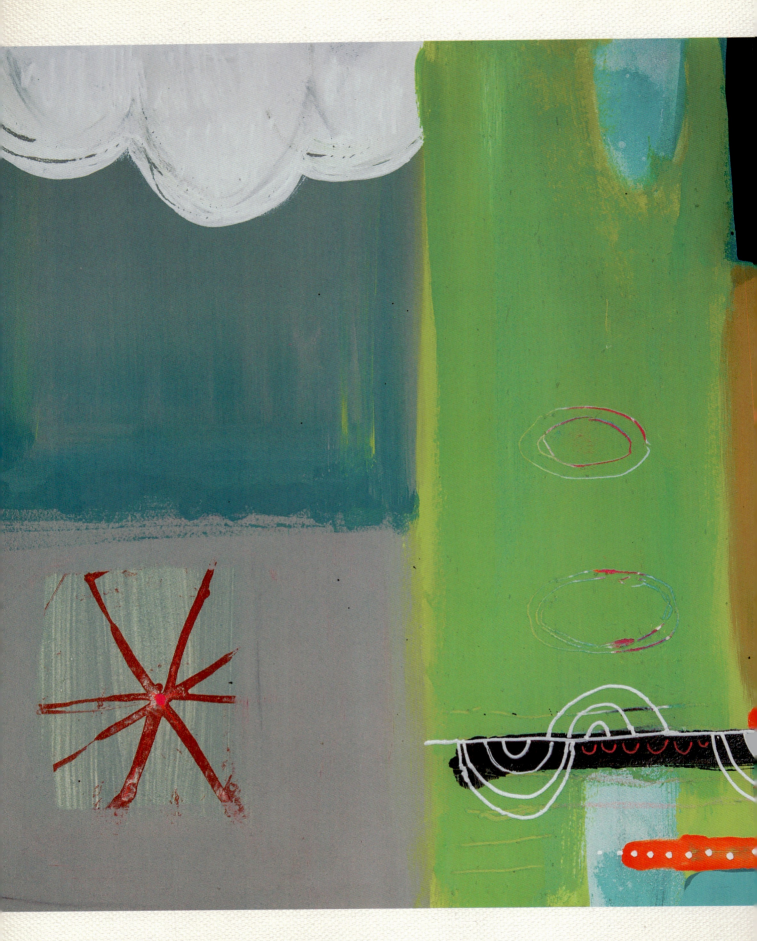

Sign up for our free newsletter at CreateMixedMedia.com.

October

It makes no difference whether a work is naturalistic or abstract; every visual expression follows the same fundamental laws.
–Hans Hofmann

Minimizing and breaking things down to their simplest form is a powerful and essential part of painting. Creating abstract work helps to free our expectations and teach us the beauty of restraint. Here, color, line, some minimal shape, texture and movement shine forth in this elemental painting technique. Abstract work is a valuable part of the painting world as it allows us to take away the unessential and focus on the essential. It allows the interpreter to take in a work as he or she pleases, to see what is there or not there. It also allows the artist to express mood and emotions in ways that are limitless.

Step-by-Step Demo: **Abstract**

What You Need

Acrylic paint
colors you enjoy, including at least one neutral

Clear spray varnish

Inks
acrylic ink or India ink

Paintbrushes
for acrylic painting: soft round/mop, flat and angled

Smock

Surface
canvas, wood panel, gesso board, Aquabord or thick watercolor paper

Water cup

Water-based paint pens
and/or Neocolor II artists' crayons

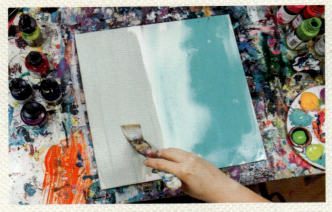
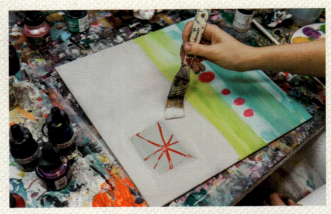
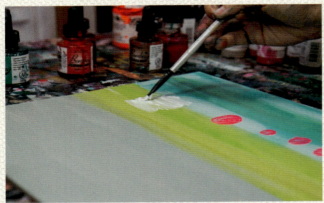
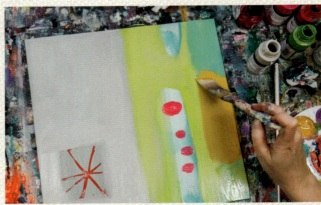
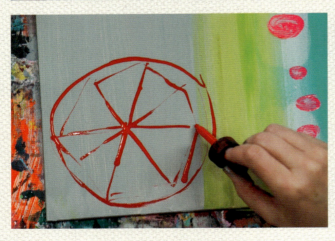
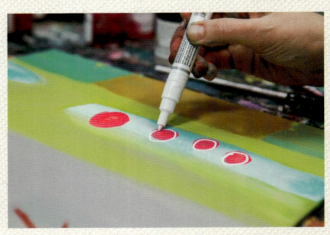

1. Choose a neutral and a color that feels fresh. I am painting on the Aquabord again—my favorite surface. I created the wash of aqua ink on the right by applying a lot of water and then balanced it out by painting with a gray matte acrylic on the left. You can work in a horizontal or vertical fashion.

Add one more color and lay it down. When the background layers are mostly dry, add a bright color that will pop—like I did here with fluorescent pink. Neutral colors really help bright colors to shine or stand out.

Add some loose and freehand marks to your piece. Allow yourself to begin to play. Here I am working directly with the bright orange dropper.

2. To create clean edges that allow the bottom layers to pop, paint with acrylics over your first layers while still leaving room for some of the underpainting to shine through. Continue to layer and add more colors, keeping the colors in a harmonious theme. I love aquas, pinks, oranges, grays, greens, a touch of black and white, and so forth. You will soon have your favorite color palettes, too if you don't already. Trust those. They speak to you for a reason.

Highlight and add refining or outlining details with paint pen. I am using both medium- and large-tip pens in this example.

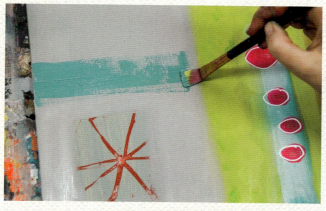
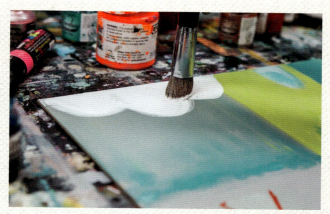
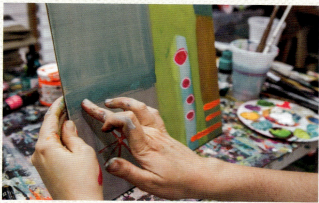

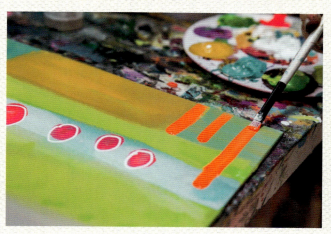

3. Continue to intuitively make marks in colors that speak to you. Simple lines or shapes go a long way.

Get personal with your work. Apply a bit of paint to the surface using a brush, then use your fingers to come in direct contact with the painting and work with it that way here and there. (Be sure to wash your hands quickly after.)

4. Adding layered element upon layered element will give depth to your painting.

Try taking a watercolor pencil and dragging it through the wet paint to create a subtle texture and mark.

Be brave and try a bold mark here and there if your intuition whispers to you.

When you feel the "click" that the work is complete (recognizing that feeling takes practice), spray it lightly with a clear varnish to preserve any delicate mark-making.

More Inspiration

A Gallery to Get You Painting!

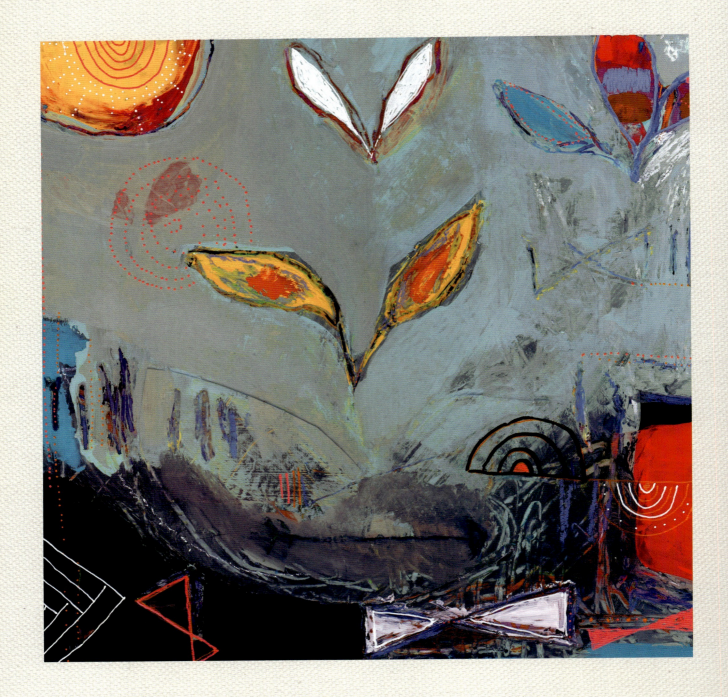

Sign up for our free newsletter at CreateMixedMedia.com.

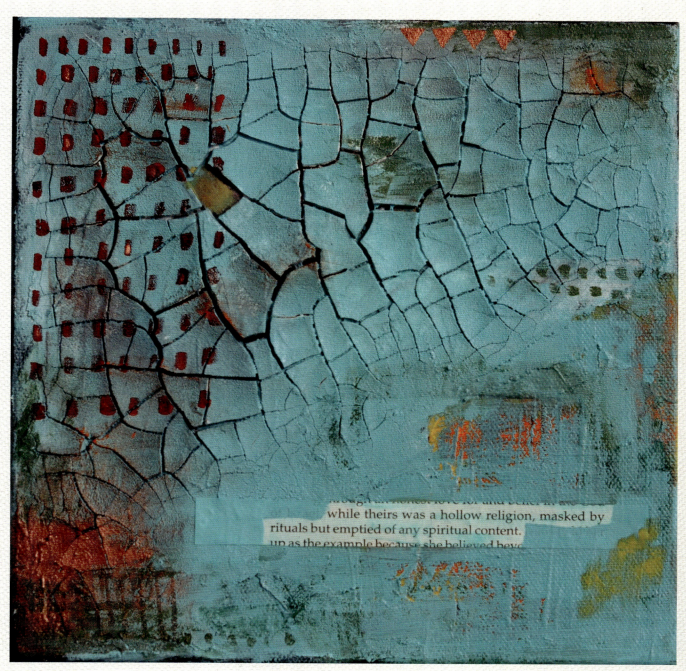

Ana Campos

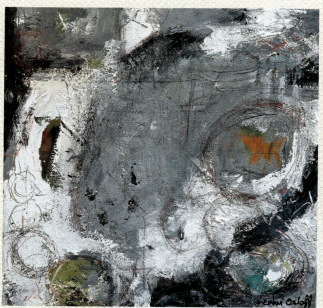

Esther Orloff

Janet Melton

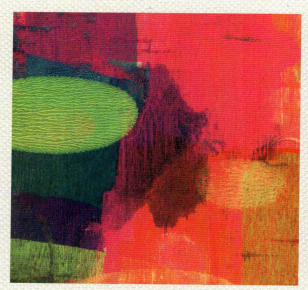

Heather Holmes

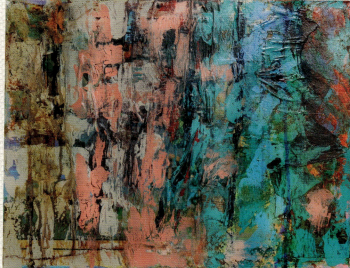

Grace Morgan

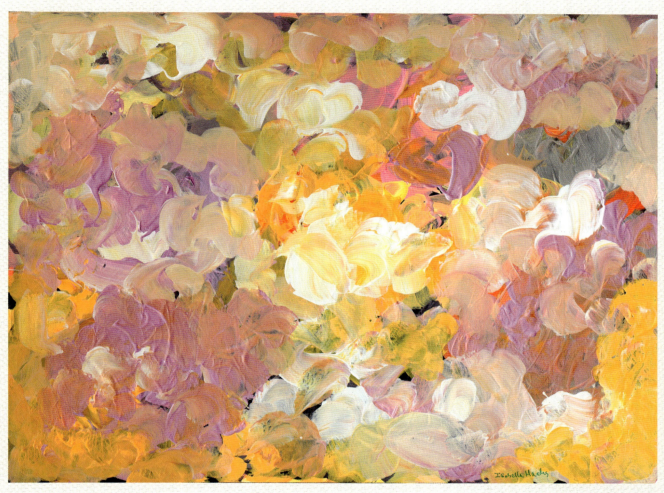

Isabella Haahs

For additional downloads from the book, go to: CreateMixedMedia.com/IntuitivePaintingWorkshop.

113

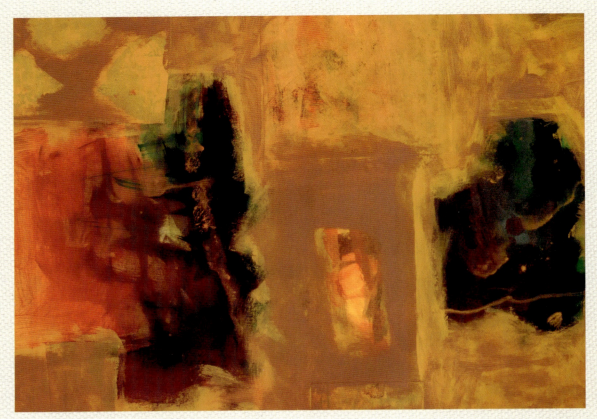

Robin Lee Devereaux

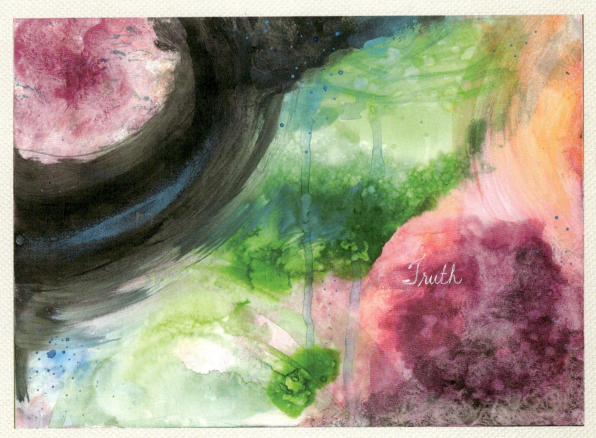

Cheryl Greene

Sign up for our free newsletter at CreateMixedMedia.com.

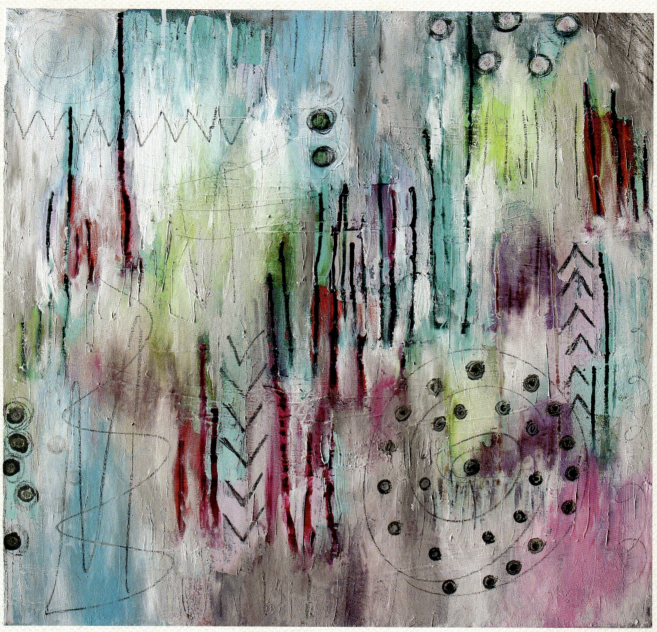

Chrissy Seufert

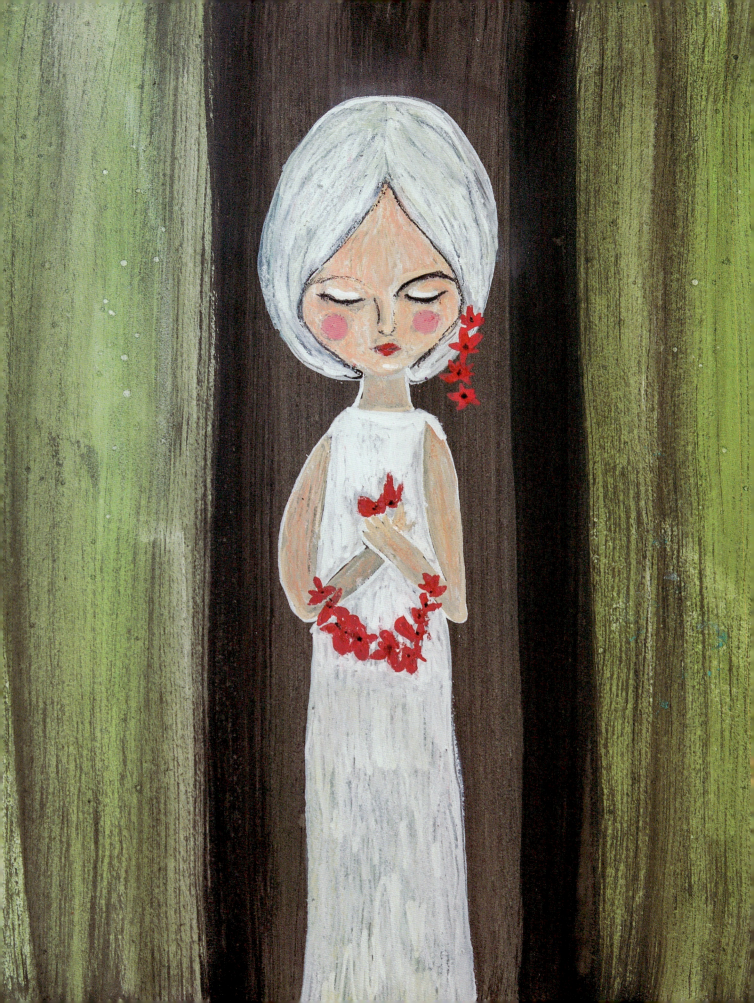

November

Though we travel the world over to find the beautiful, we must carry it with us or we find it not.
– Ralph Waldo Emerson

This month we travel east to Japan and other worldly places to paint (even if it's just in our imagination). Here the symbolic, quirky, flat and dreamy illustrative style of Japanese art will inspire and motivate new ways of seeing and creating. When we learn to see how other parts of the world take in their surroundings and express them through paint, we learn so much not only as artists but also as humans.

Do a Web search on Japanese artists or Japanese art and look through images until you find some that speak to you. Print several of them out to use as references. Take your time with this and choose some that you will be inspired to paint from!

Step-by-Step Demo: **Eastern Influences**

What You Need

Acrylic paint
colors you enjoy, including at least one neutral

Clear spray varnish

Inks
acrylic ink or India ink

Paintbrushes
for acrylic painting: soft round/mop, flat and angled

Paper towel

Pencil

Smock

Surface
canvas, wood panel, Gessoboard, Aquabord or thick watercolor paper

Water cup

Water-based paint pens
and/or Neocolor II Artists' Crayons

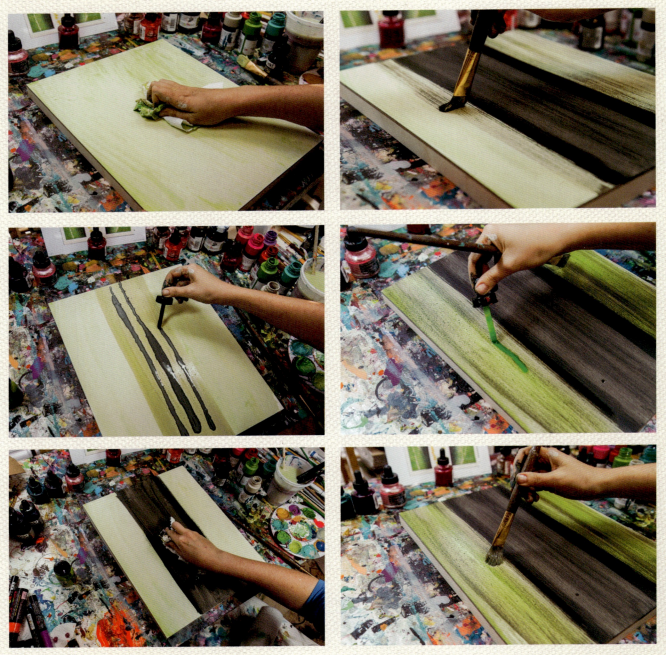

1. Make a simple yet elegant background with just a few colors. Here I wet the Aquabord and then applied a light green ink. I blotted up the excess water or air bubbles with a paper towel, and then applied black ink into the center for a contrasting effect. Using a paper towel, I rubbed paint off down the center, leaving darker lines on the outsides.

2. I drybrushed any remaining black ink over the green parts to create an implied texture, almost like a good grain. I did this simply by using a dry thick brush and dragging into the semi-dry black ink. I then added a little more bright green ink over it to give the background another layer—or more depth.

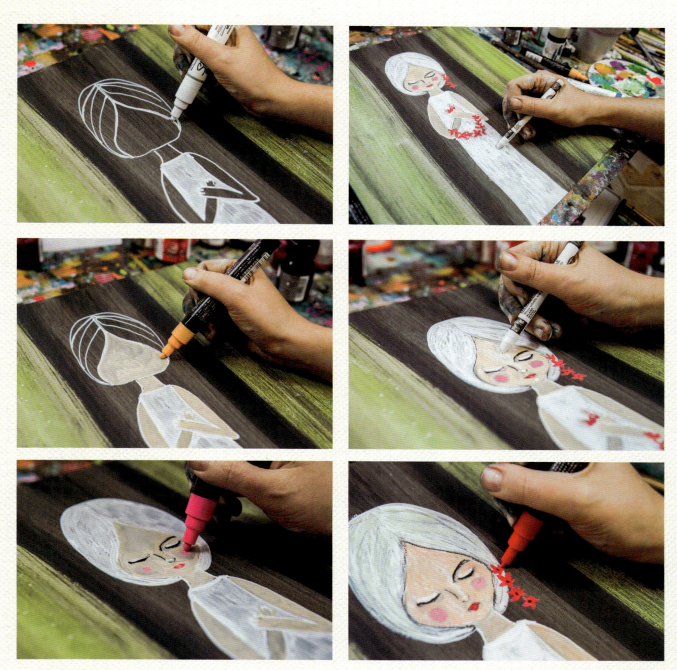

3. Japanese paintings are pretty flat or surface based, and they
 have a whimsical illustrated quality to them. Begin to sketch
 in your subject matter with a pencil or paint pen. Look to
 your inspirational pieces but do not copy them outright.

 Because I am creating a female figure, I used a beige (or
 flesh tone) water-based paint pen, and used a fine tip for her
 features (eyes, lips, nose) instead of a medium tip. I did use
 a medium tip for the rest of her, including her rosy cheeks.

4. When the paint pen is dry, add more details to your subject
 and refine the edges and lines by using your fine-point paint
 pens. I have found Japanese art to tell a story of some sort,
 along the lines of innocence and purity of being. What would
 you like yours to convey?

 Finish off the painting by adding more details with the
 paint pens (it's always good to step away for a while and
 then revisit it with fresh eyes). Seal the painting with a clear
 spray varnish once it is complete.

More Inspiration

A Gallery to Get You Painting!

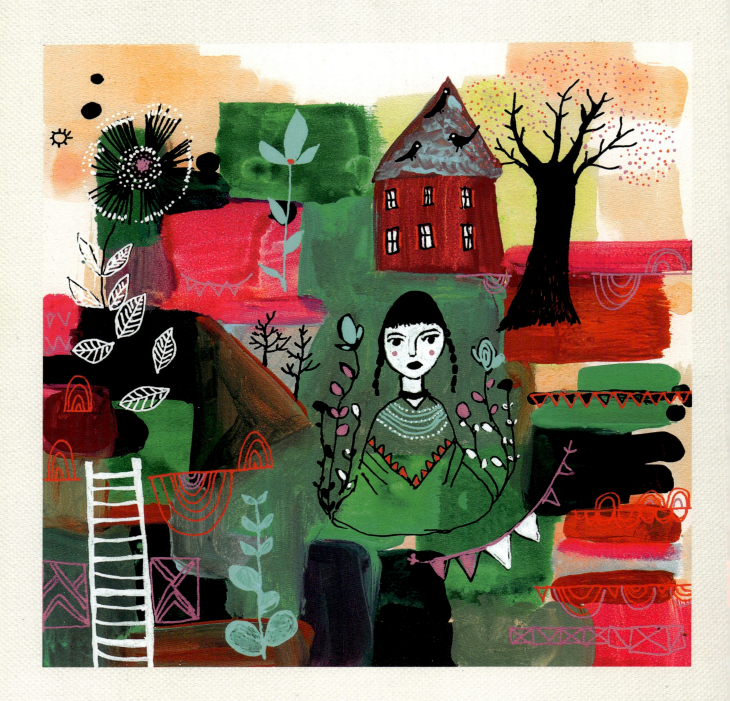

Sign up for our free newsletter at CreateMixedMedia.com.

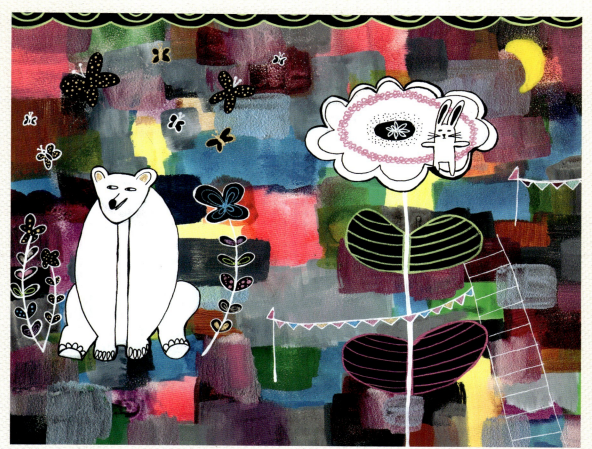

Heather Holmes

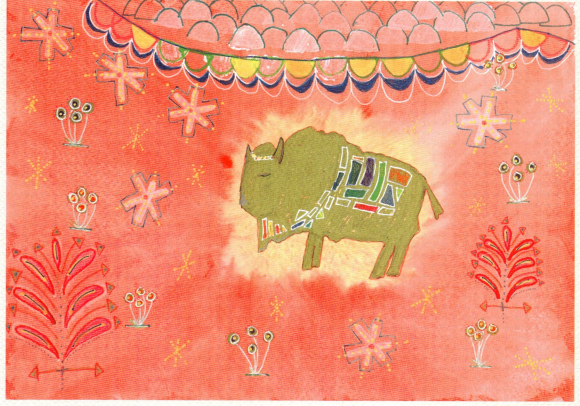

Michele Kittell

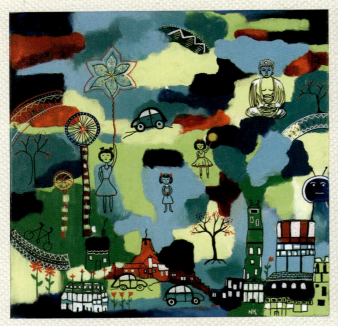

Navneet Khalsa

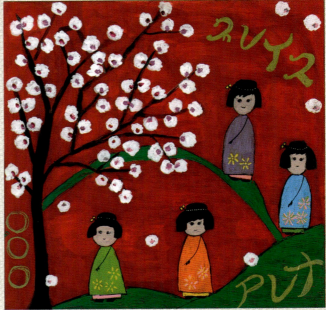

Ciarrai Samson

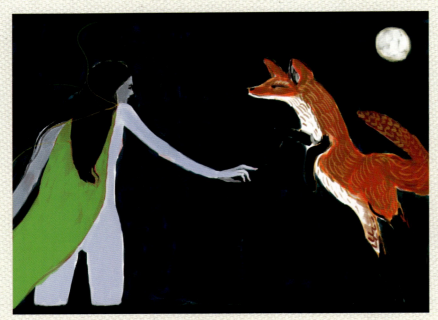

Tara Francesca

Lara Cornell

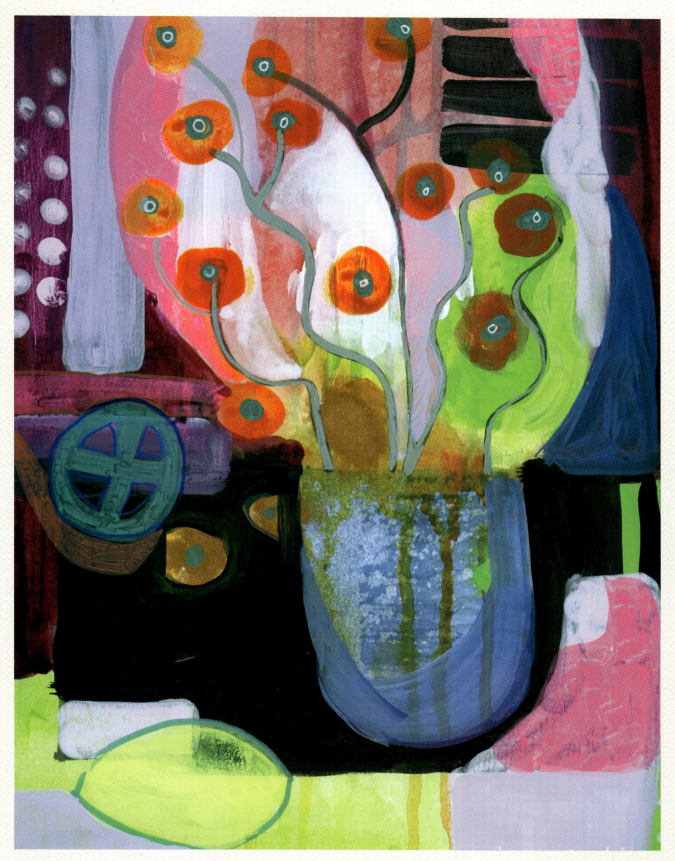

Julia Godden

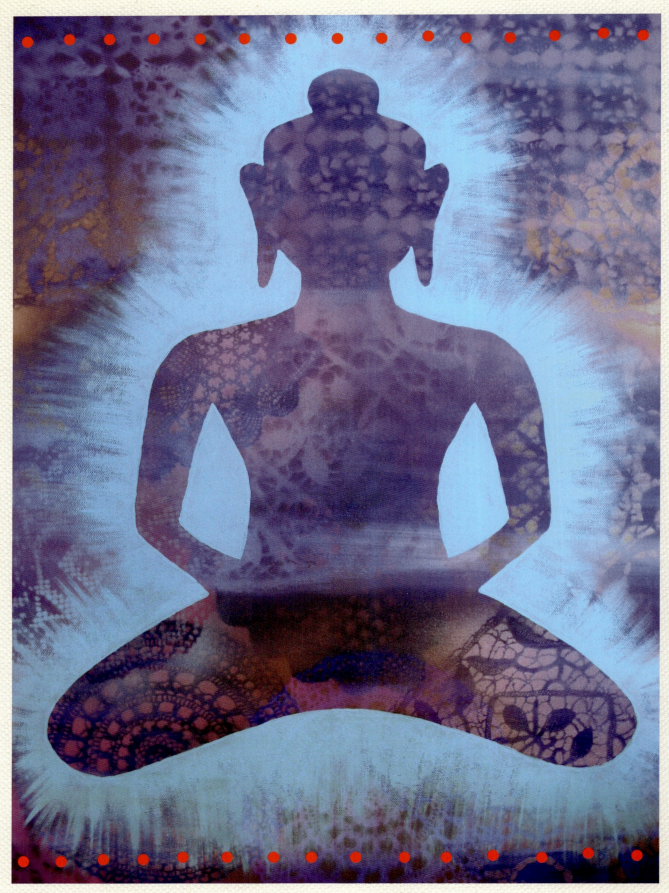

Cat Athena Louise

Sign up for our free newsletter at CreateMixedMedia.com.

Winter Check-In

Winter is the time for comfort, for good food and warmth, for the touch of a friendly hand and for a talk beside the fire: it is the time for home.
—Edith Sitwell

Winter is a perfect time for painting. The cold weather outside provides for more inside time for creativity and imaginary worlds. Spend this winter with your paints and brushes and warm up your creative fire from within—express yourself in festive merriment or quiet reflection that is fitting for this time of year.

Journaling Prompts

- In what ways can you take more time for your art now that it's winter?
- How can you bring the silent element of winter—that which is bare, still, and cold to the touch—into your work? What colors speak to you most during this season of stillness?
- Try making painted works as gifts or cards to give to your loved ones this holiday. What sort of messages would you like each card to say?

Practice drawing and painting some symbols of winter.

For additional downloads from the book, go to: CreateMixedMedia.com/IntuitivePaintingWorkshop.

125

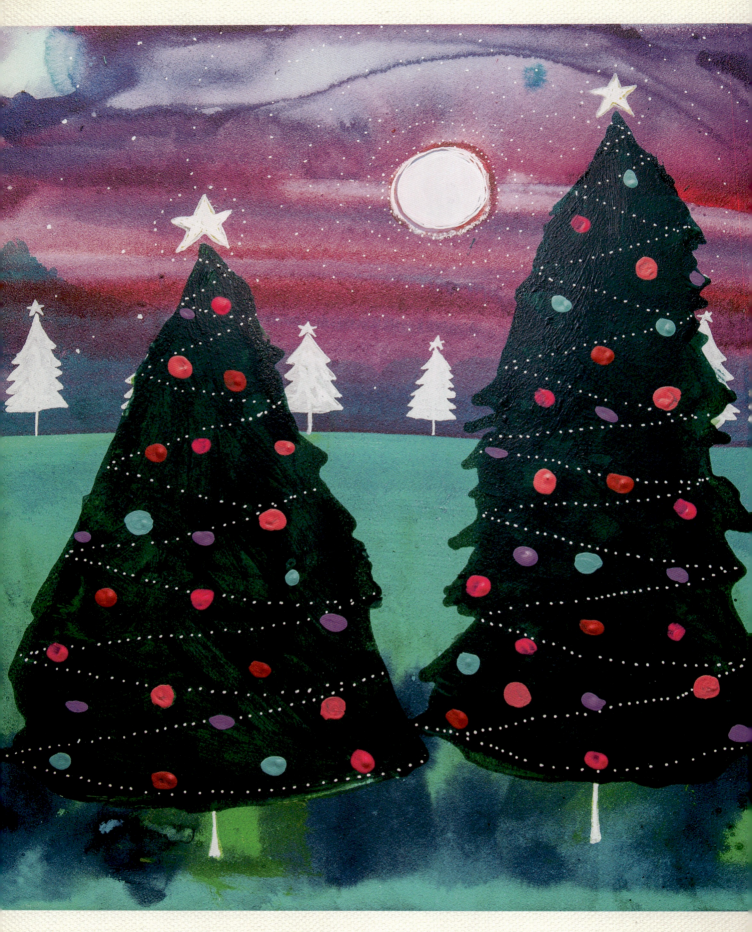

December

With the year now coming to a close, what a perfect way to celebrate by making a painting just in time for the holidays. Sparkle, reds, greens, animals or trees representative of a seasonal expression are all part of this month's inspiration. Choose this lesson to be one where you celebrate the holidays in joyful merriment of painting and creativity, choosing from different techniques that this book has given through out the year. Let this year come to a close in sweet reflection, for all that you have gained.

For this lesson, it's really up to you as to how you would like to execute it. You can follow as I have done here in the step-by-step photos, or you can take certain techniques we've learned this year and combine them or repeat a lesson but just making it holiday themed. The point of this lesson is to celebrate the season and create a painting that is inspired by it.

Step-by-Step Demo: **Holiday Painting**

What You Need

Acrylic paint
colors that feel festive!

Clear spray varnish

Inks
acrylic ink or India ink

Paintbrushes
for acrylic painting: soft round/mop, flat and angled

Smock

Surface
canvas board, wood panel, Gessoboard or Aquabord

Water cup

Water-based paint pens
and/or Neocolor II Artists' Crayons

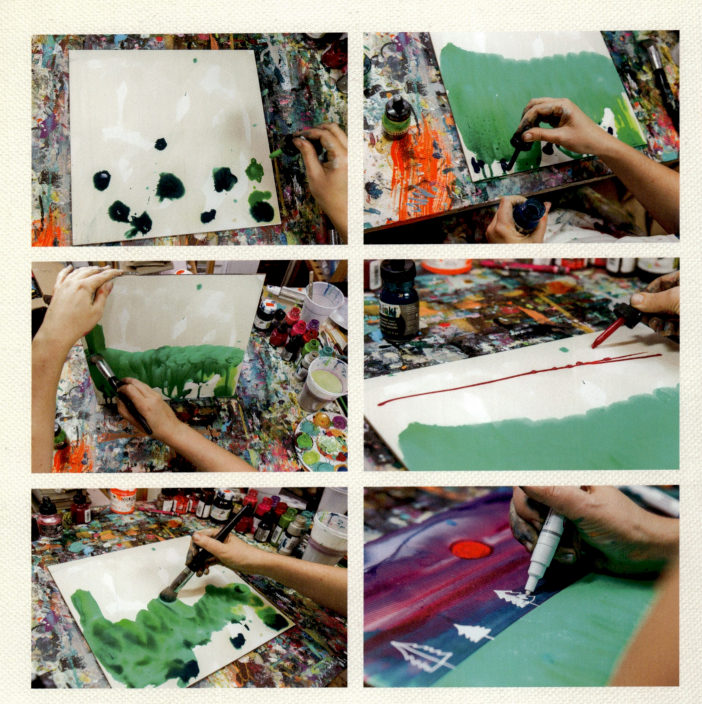

1. Begin by painting your background with rich jewel tones, or use greens and blue inks (analogous colors) as I have done here on the Aquabord. Drop the inks all over the surface and allow them to naturally feather.

Allow drips to naturally occur by tapping your surface up vertically. Just make sure a lot of water is applied to be able to pull off this effect. Swirl them around with a mop brush or other thick round brush.

2. I like having a loose inky feel, one that is translucent for the background overlaid with opaque subject matter. Continue to work with rich holiday colors for your background. I love magenta, red and green jewel tones. Define a horizon line of some sort. Here I drew in white trees with paint pen. I also drew a moon with my wax crayon.

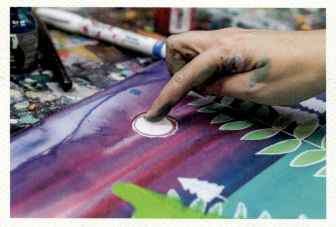
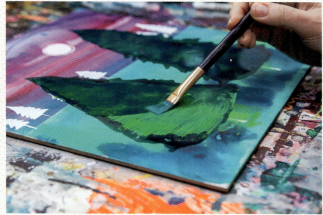
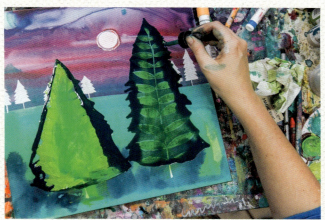
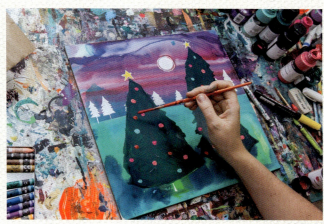
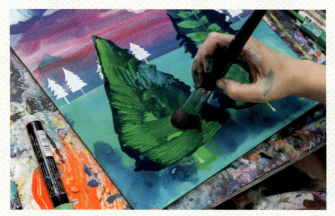
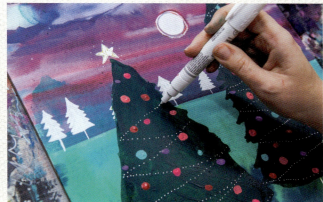

3. I then added white acrylic paint over it. Paint a foreground for your work. This is a very simple painting in which I am drawing two Christmas trees. The images for your foreground may be totally different; it's really up to you and how you celebrate the holiday season.

In this example I am using several different green inks to create trees that are saturated with color. I am also applying green matte acrylics once the inks are mostly dry. I want the trees to feel solid on my painting and hold stature. Layering can help to accomplish this.

4. Take your painting a bit further with more detail, as I am doing here by painting ornaments on the tree. I picked out more bright colors to express the celebratory mood of the holidays. I am using a small round brush to execute these ornaments.

Continue to draw in lovely details, as I have done here with my white ornamental dots around the moon and on the tree. These dots help to create a sense of movement and show up sweetly against a sweeping sky. This lesson would be fun to do on smaller surfaces, and then give each to a family member, or to do with your family as a holiday activity when the kids are home.

Spray or apply liquid varnish to seal the painting.

More Inspiration

A Gallery to Get You Painting!

Sign up for our free newsletter at CreateMixedMedia.com.

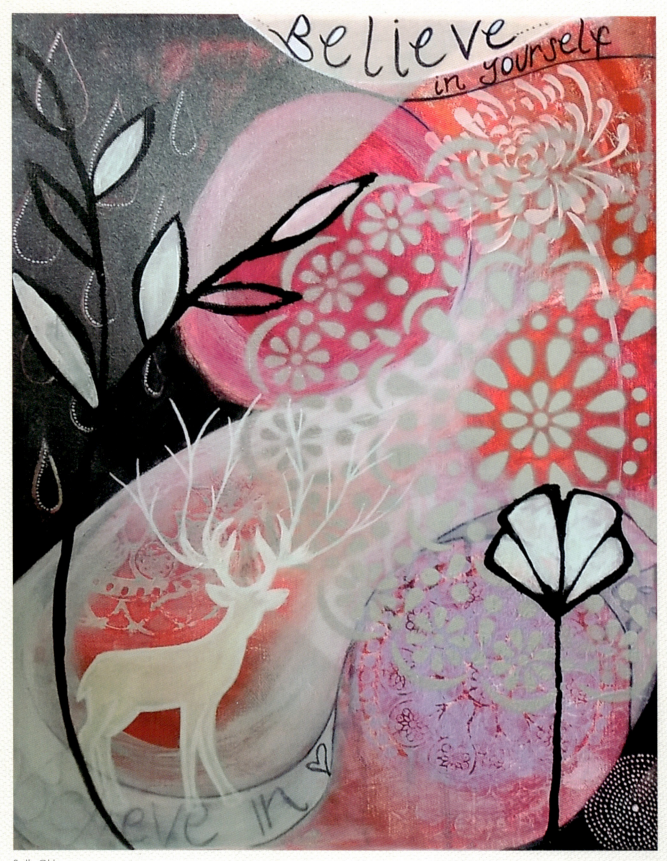

Sally Okkerse

For additional downloads from the book, go to: CreateMixedMedia.com/IntuitivePaintingWorkshop.

131

Jessica Kinsella

Claire Sheehan

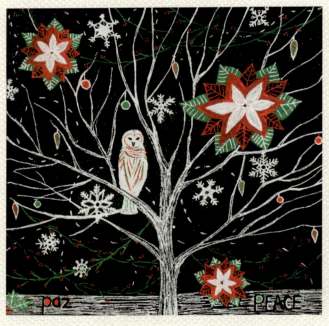

Colleen Gaynor

Paula Madonna

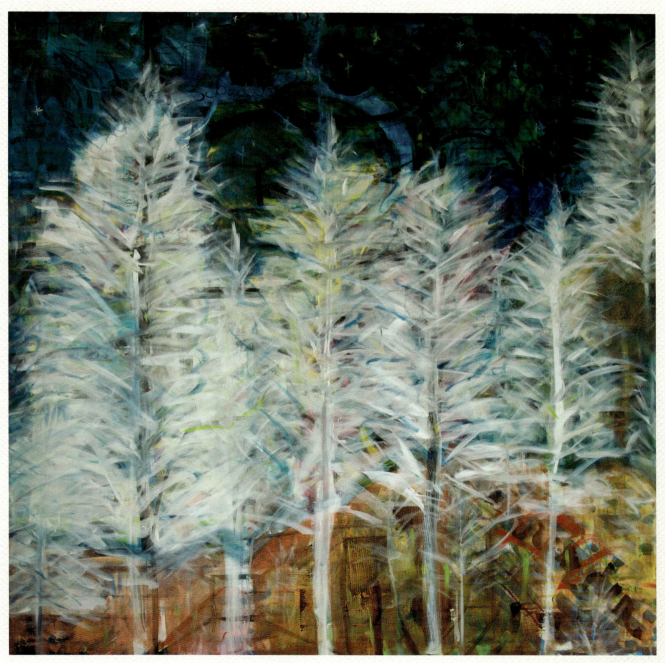

Michele Kittell

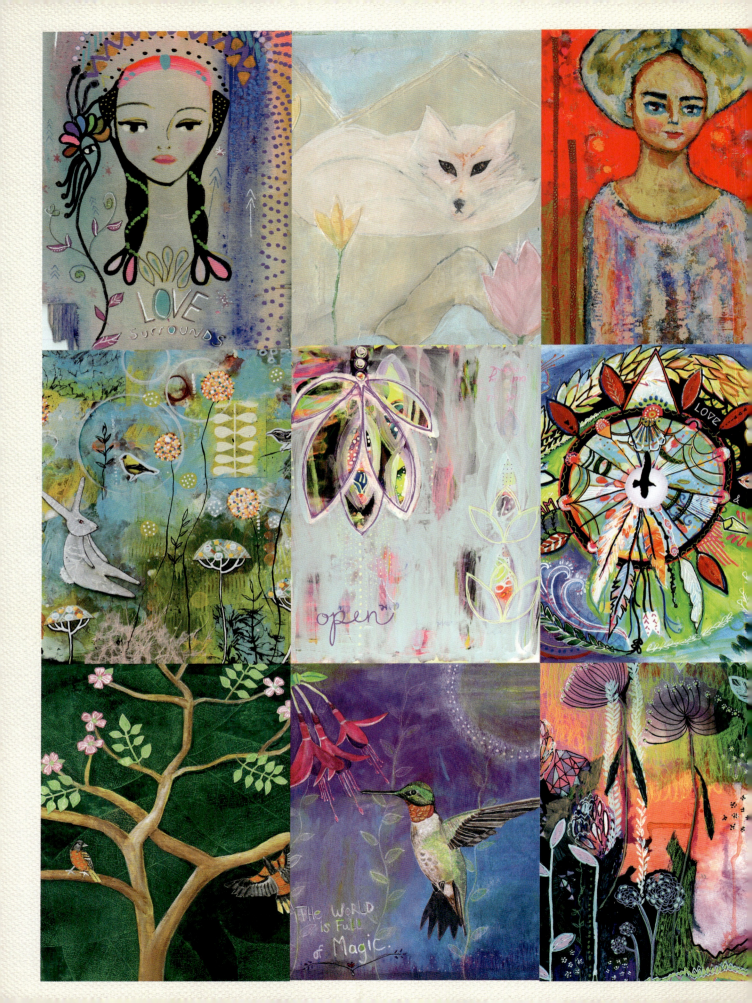

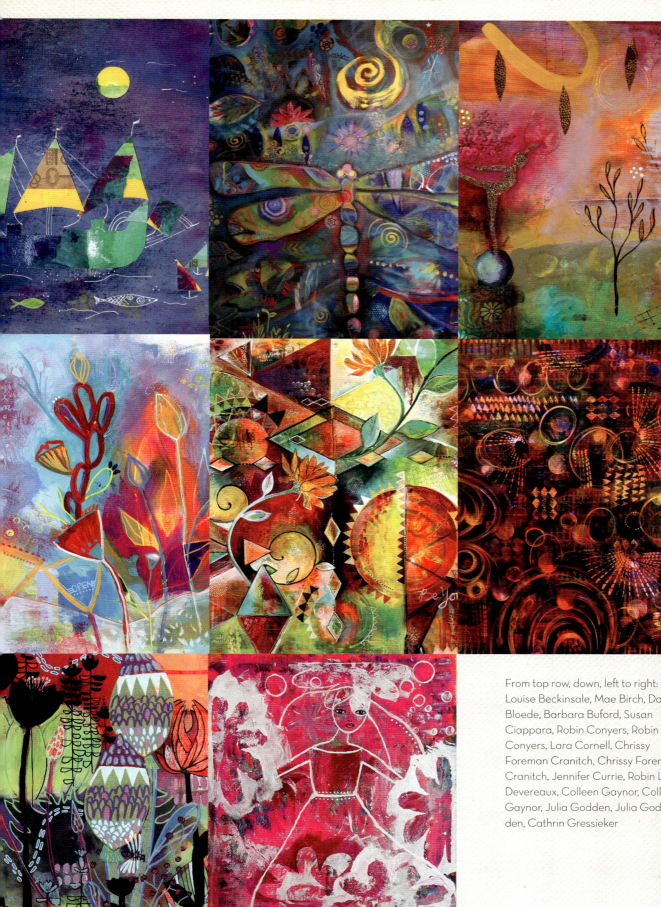

From top row, down, left to right:
Louise Beckinsale, Mae Birch, Dana
Bloede, Barbara Buford, Susan
Ciappara, Robin Conyers, Robin
Conyers, Lara Cornell, Chrissy
Foreman Cranitch, Chrissy Foreman
Cranitch, Jennifer Currie, Robin Lee
Devereaux, Colleen Gaynor, Colleen
Gaynor, Julia Godden, Julia God-
den, Cathrin Gressieker

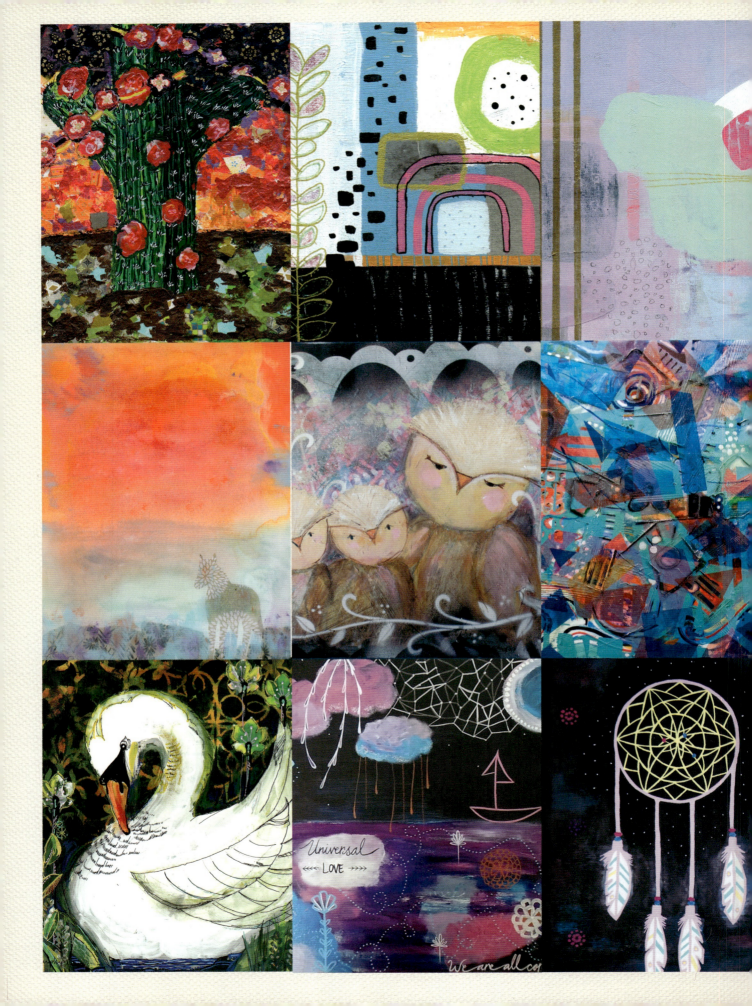

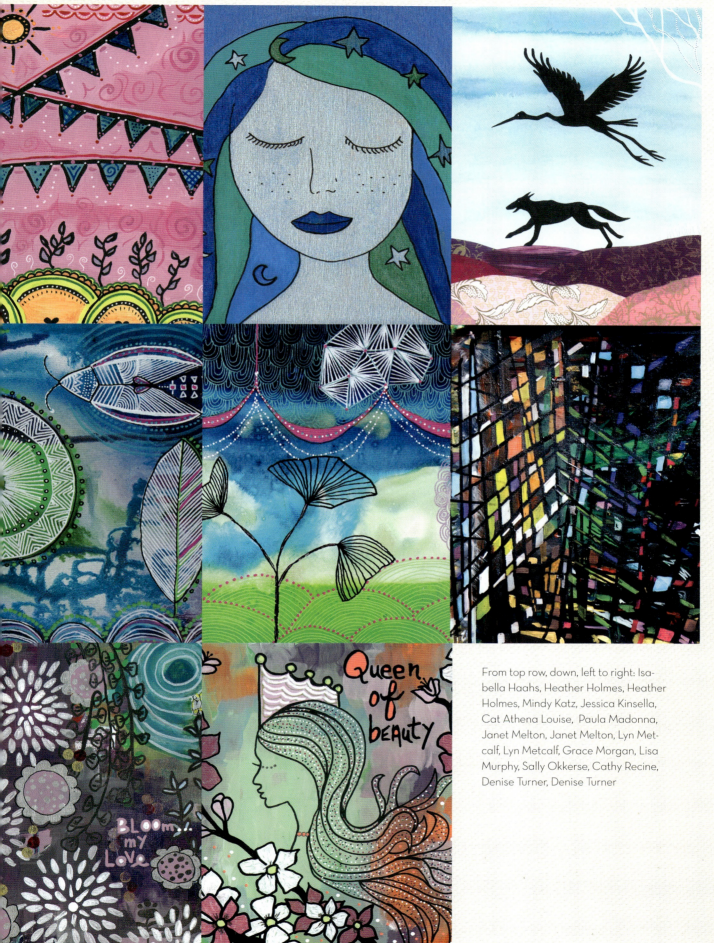

From top row, down, left to right: Isabella Haahs, Heather Holmes, Heather Holmes, Mindy Katz, Jessica Kinsella, Cat Athena Louise, Paula Madonna, Janet Melton, Janet Melton, Lyn Metcalf, Lyn Metcalf, Grace Morgan, Lisa Murphy, Sally Okkerse, Cathy Recine, Denise Turner, Denise Turner

Contributing Artists

I have so much gratitude to all the wonderful artists who created work in my *A Year of Painting* online class. The folks in these classes continue to inspire me to no end. I am greatly moved by each of these contributors (who all happen to be women) on how they see the world and how uniquely beautiful they express it.

Here is a list of those whose work is a part of this book.

Emily Ankeney emilyankeney.com

Louise Beckinsale louisebeckinsale.com

Mae Birch maebirch.com

Michelle Blades

Dana Bloede danabloede.com

Barbara Buford

Ana Campos ana-campos.com

Janine Canady

Susan Ciappara sukihealingarts.com

Robin Conyers robinconyers.com

Lara Cornell laracornell.com

Juliette Crane juliettecrane.com

Chrissy Foreman Cranitch chrissyforemanc.com.au

Jennifer Currie jennifercurrie.com

Robin Lee Devereaux

Alejandra Equiza

Tara Francesca tarafrancesca.com

Colleen Gaynor colleengaynor.com

Ida Glad idaglad.dk

Julia Godden juliagodden.com

Cheryl Greene

Cathrin Gressieker

Isabella Haahs isabellasartstudio.com

Jane Hennessy

Heather Holmes

Amanda Jennings

Mindy Katz mapanddesign.com

Navneet Khalsa

Rebecca Kim

Jessica Kinsella jessicakinsellaart.com

Michele Kittell michelekittell.com

Marika Lemay marikalemay.com

Kimberly Leslie

Susanne Leusman susanne-leusman.com

Cat Athena Louise catathenalouise.com

Paula Madonna paulamadonna.com

Janet Melton

Lyn Metcalf

Grace Morgan gracemorganarts.com

Lisa Murphy lisamurphyart.wordpress.com

Sarah Nakatsuka sarahnakatsuka.com

Sally Okkerse sallyokkerse.com

Esther Orloff emakesart.blogspot.com

Cathy Recine

Rachael Rice rachaelrice.com

Ciarrai Samson

Renee Scheer reneescheer.com

Chrissy Seufert chrissyseufert.com

Claire Sheehan

Kristi Shreenan

Laura Sorranno

Jeanne Tierno jeannetierno.com

Karin Tintle

Colette Trad paperwoodsilk.com

Lisa Tsering lisamarietsering.com

Denise Turner positivelyart.ca

Kelly Zarb kellyzarb.com

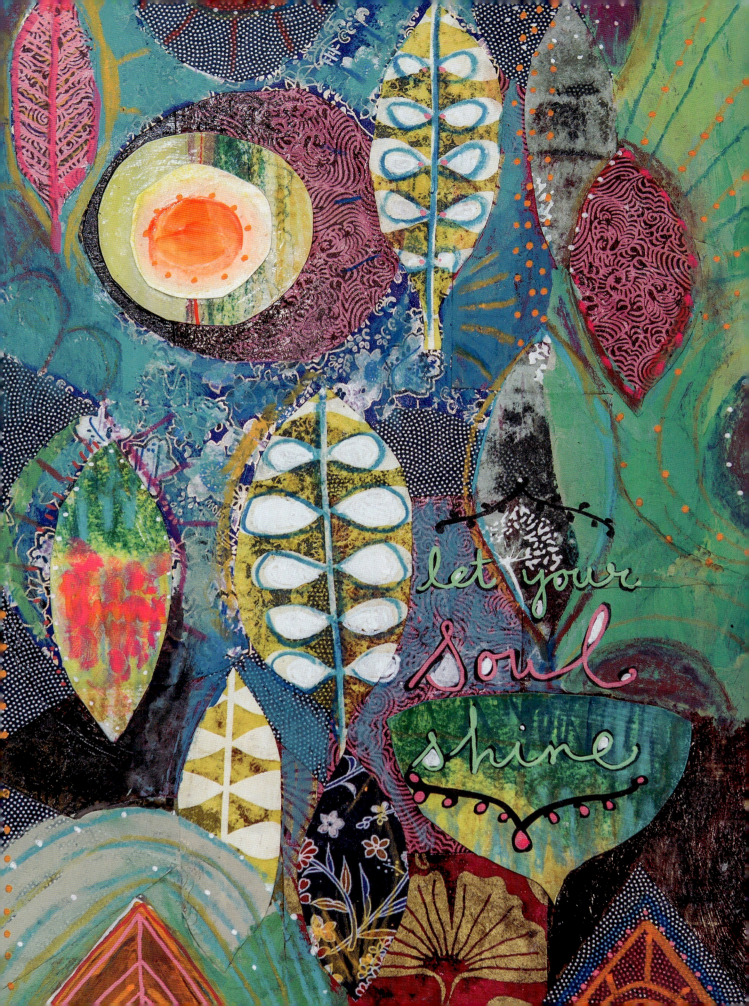

Index

Dedication

To all the visual artists of the world, both beginning and experienced: This book is for you and for our love of painting. May we never stop creating to satisfy our souls. May we continue to express what is beyond words. May we paint into the quiet hours of the night and at the delightful start of daybreak. May we continue to evolve as creators and never stop being students of this fine craft. May we always see painting as a celebration and metaphor for life.

And to my *Year of Painting* artists: You are lovely and gifted creatures! How brave you were to show up and paint for a whole year, some experienced and others just beginning. This book is truly dedicated to you.

Acknowledgments

This happens to be the third art book I have created in just three years. The thought is startling and gratifying all at once. I now sit in my quiet studio reflecting on just how I got to this point and why and just who I should be acknowledging . . . I begin to think about all the artists I have met along the way, whether I knew their names or not, and how they inspired me to believe in my dreams and be true to myself. I remember going through phases of both challenge and abundance, until one day the steady stream of making a living as a full-time artist seemed to just open up with grace and ease. What truly comes to mind when I reflect upon my artist path is that I did not give up. I kept doing the work and I noticed, from making that effort, opportunities and blessings came forth. The year this book comes out also marks my tenth year as a full-time professional artist. My, how the time has flown! So although I have a list of numerous people I have met along my artist path, some I can recall, others I know I have forgotten, just know that in my heart I am grateful our paths did cross. To all my art teachers, art friends, family and loved ones . . . and to those who have supported me along the way: I thank you with my whole heart. I know you helped make this possible.

A sincere thank you to the delightful Tonia Jenny, who believed in this book and whom I also consider a dear friend.

I would also like to thank my parents, Jane Hennessy and Joseph Thomas, whom I love and treasure dearly. Your open minds and hearts have been instrumental for me on this path. It has not always been easy, but it's been so worth it. I love you both so much.

To all my dear friends here in Asheville and across the globe: I adore you. To my artist tribe of powerful and dynamic women such as Susan Tuttle, Michelle Madden Smith, Jen Grey Blackburn, Flora Bowley, Pixie Campbell, Rachael Rice, Mati Rose, Anahata Katkin and so many more: You all are stars. Keep shining.

To my partner, Matthew Beasley: You are a genius in every way, dear; I love you so much. Thank you for coming into my life and changing my world.

And finally, to the shiny beautiful and bright artists in *A Year of Painting*: You all rock my world every day and I am utterly grateful for you in every way. I'm so madly in love with our community. Thank you sincerely for showing up for yourself in this way and creating such authentic beauty.

Other fine North Light Books are available from your favorite bookstore, art supply store or online supplier. Visit our website at fwmedia.com.

19 18 5 4 3

a content + ecommerce company

DISTRIBUTED IN THE U.K. AND EUROPE
BY F&W MEDIA INTERNATIONAL LTD
Brunel House, Forde Close, Newton Abbot, TQ12 4PU, UK
Tel: (+44) 1626 323200, Fax: (+44) 1626 323319
Email: enquiries@fwmedia.com

ISBN 13: 978-1-4403-4240-0

Edited by Tonia Jenny
Designed by Corrie Schaffeld
Production coordinated by Jennifer Bass

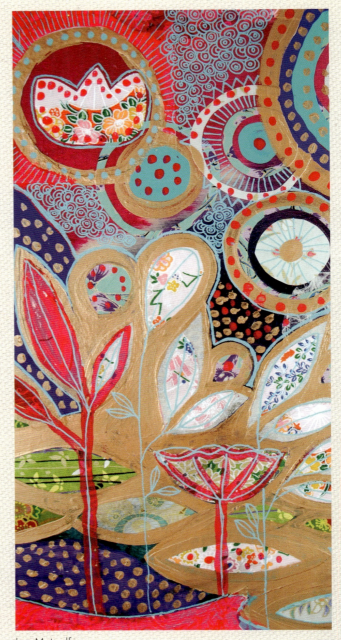

Lyn Metcalf

Metric Conversion Chart

To convert	to	multiply by
Inches	Centimeters	2.54
Centimeters	Inches	0.4
Feet	Centimeters	30.5
Centimeters	Feet	0.03
Yards	Meters	0.9
Meters	Yards	1.1

About Alena

Alena Hennessy began making art at a very young age, way before she could write. She would spend hours upon hours drawing on the back of her grandmother's dittos from school, making up imaginary worlds of falling umbrellas, rainbow puddles, ant farms underground, horses with varying personalities and some very fashionable ladies. Since then her love of creating has evolved, branching out with a deep desire to assist others in finding their true voices in painting and mixed-media art.

Alena is also the author of *Cultivating Your Creative Life* and *The Painting Workbook* and is a beloved teacher of the art-making process, both online and at select retreats. Her work has been featured in numerous magazines and publications including, *The Washington Post*, *Somerset Life*, *Spirituality & Health*, *ReadyMade*, *Redbook*, *Stitch*, *Victoria*, *Dwell* and *Natural Health*, as well as being featured on *Good Morning America* and pilot shows for ABC Studios. Her paintings have been exhibited across major cities in the United States, along with several museum shows. Alena is also a flower essence practitioner along with being a Reiki master and energy healer. Through grace and intuitive guideposts, she calls the beautiful town of Asheville, North Carolina, her home, with her gifted partner, Matthew, and sweet Pomeranian fur child Mimi Simone. As a facilitator, her intention is that each participant leaves a little more transformed, content and open to wild possibility.

To take a class with Alena online or to see more of her work and to find out more, visit her online at alenahennessy.com.

Ideas. Instruction. Inspiration.

Receive FREE downloadable bonus materials when you sign up for our free newsletter at CreateMixedMedia.com.

ABSTRACT ART EXPLORATIONS
17 ACRYLIC PAINTING TECHNIQUES
WITH CHRIS COZEN

NORTH LIGHT DVD | an artistsnetwork.tv production

Painted Blossoms

CREATING EXPRESSIVE FLOWER ART
with MIXED MEDIA

CARRIE SCHMITT

COLLABORATE! 8 TIPS FOR MAKING ART WITH FRIENDS p. 32

CELEBRATE SUMMER! 6 PROJECTS INSPIRED BY NATURE

cloth·paper
scissors®

collage with embossed metal

print on tea bags

flower power
paint a summer bouquet!

Find the latest issues of *Cloth Paper Scissors* on newsstands, or visit shop.clothpaperscissors.com.

These and other fine North Light products are available at your favorite art and craft retailer, bookstore or online supplier. Visit our websites at createmixedmedia.com and artistsnetwork.tv.

Follow CreateMixedMedia.com for the latest news, free wallpapers, free demos and chances to win FREE BOOKS!

Get your art in print!

Visit CreateMixedMedia.com for up-to-date information on *Incite* and other North Light competitions.

INCITE 2
COLOR PASSIONS

INCITE 3
The Art of Storytelling
THE BEST OF MIXED MEDIA

edited by TONIA JENNY